GP 5/30

D0747090

SPIRIT FACES

CONTEMPORARY MASKS OF THE NORTHWEST COAST

GARY WYATT

Douglas & McIntyre

Vancouver/Toronto

University of Washington Press

Seattle

Copyright © 1994 by the Inuit Gallery
99 5

All rights reserved. No part of this book may be reproduced
or transmitted in any form by any means without permission
in writing from the publisher, except by a reviewer, who
may quote brief passages in a review.

Douglas & McIntyre, 1615 Venables Street
Vancouver, British Columbia V5L 2H1

Published simultaneously in the United States of
America by the University of Washington Press,
P.O. Box 50096, Seattle, WA 90145 5096.
ISBN 0-295-97758-2

Canadian Cataloguing in Publication Data
Wyatt, Gary R.
Spirit faces

ISBN 1-55054-145-5
1. Indians of North America—British Columbia—
Pacific Coast—Masks.
2. Masks—British Columbia—Pacific Coast.
I. Title.
E78.N78W92 1994 731'.75'089970711
C94-910211-3

Editing by Saeko Usukawa
Design by RayMah Design,Inc.
Photographs by Kenji Nagai,
Trevor Mills and Robert Keziere

Front cover: *Crooked Beak* mask 1992,
by Glenn Tallio (Nuxalk)
Back cover: *Dzunukwis* mask 1987,
by Beau Dick (Kwakwaka'wakw)

Printed and bound in Hong Kong
by C & C Offset Printing Co. Ltd.

CONTENTS

LIST OF MASKS

PREFACE

There are many people to whom I am grateful for their efforts and support in bringing this book into existence. I would especially like to thank Joseph Murphy, the director of the Inuit Gallery, for giving me the opportunity to work with this magnificent collection. His vision of exhibiting and representing Inuit and Northwest Coast art in the context of fine art has greatly enhanced their recognition as equals to the world's other great artforms, past or present.

All the artists deserve thanks for the privilege of working with them and their art, as well as for their support on this project and for checking the text from many different viewpoints.

I would like to thank Derek Norton, who read and revised many drafts of the introduction. My other colleagues at the Inuit Gallery, Colin Choi, Glenn Lahey, James Leasak, Nigel Reading and Melanie Zavediuk, gave me much needed assistance, which I greatly appreciate.

The three photographers, Kenji Nagai, Trevor Mills and Robert Keziere, must be acknowledged for their artistic presence, which is felt throughout the book.

I am grateful to Scott McIntyre and the staff of Douglas & McIntyre, the publishers, for their support and understanding of the importance of this book, and particularly to my editor, Saeko Usukawa, who, beyond her professional expertise, was a pleasure to work with.

My thanks to Dennis Wilson, Tom Wilford, Pam Hollingsworth and the rest of the staff of D.W. Air in Blaine, Washington, for their help.

For their patience and understanding, I am indebted to my family: Marianne, Leif, Adrianah, Ellen and Noah.

Finally, a thank you to the many collectors who support this artform and recognize its place in the world of art.

All masks appear courtesy of private collectors and the Inuit Gallery of Vancouver.

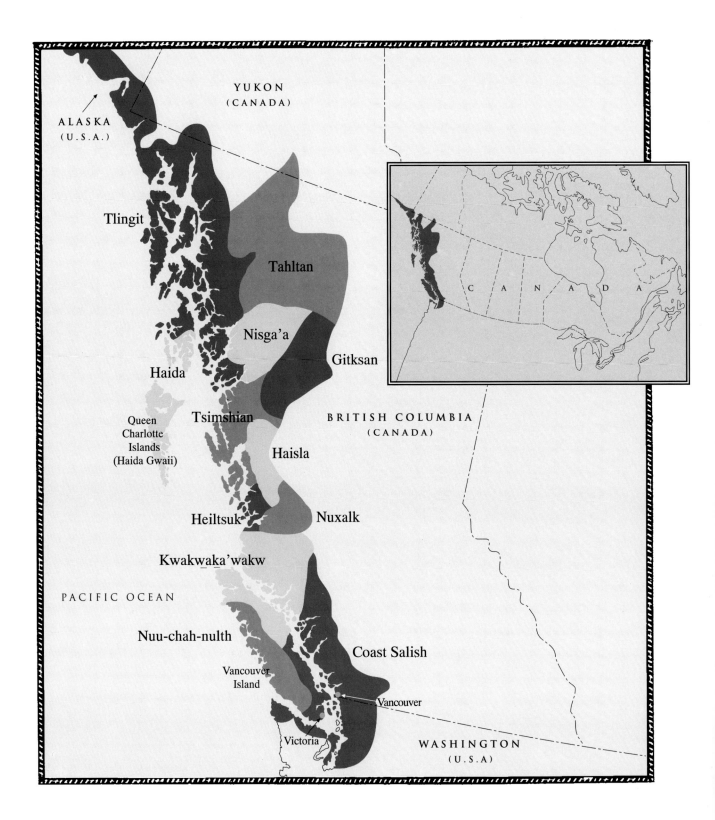

INTRODUCTION

The indigenous peoples of the Northwest Coast of North America constitute one of the world's oldest and richest cultural groups. For thousands of years they have lived along the Pacific shoreline of what is now mostly the province of British Columbia, Canada. The area is bounded by Alaska to the north, the Coastal Mountains to the east, the Columbia River to the south, and the Pacific Ocean to the west.

The favourable environment of the region, with its temperate climate and abundance of food, especially salmon, made it possible for the people to establish permanent villages. The settled way of life and secure supplies of food enabled them to develop a sophisticated social and ceremonial life that was greatly enriched by a variety of beautifully decorated objects, the best of which reached the level of great art.

The Northwest Coast comprises many nations, as can be seen from the map in this book, of which the major groups are the Tlingit, Haida, Tsimshian, Kwakwaka'wakw (also spelled Kwakiutl or Kwagiulth), Nuxalk, Nuu-chah-nulth and Coast Salish. To the untrained eye, the art has enough similarities to be mistakenly considered a single homogeneous identity, but over the centuries each group developed its own artistic style, in addition to its own mythology and ceremonial practices.

The societies were rich enough and concerned enough with aesthetics to foster and maintain individual artists to create objects such as masks for ceremonial functions, as well as objects such as paddles for everyday use. Artists worked in the set style of their village or tribe, since that was the cultural idiom they learned as apprentices and that their audience recognized. Outstanding artists introduced innovations and modifications that established personal styles within cultural confines, to keep the art fluid and current.

By the 1820s, only a few decades after contact with Europeans, one group, the Haida, had already begun to produce art for sale to visitors and to museums, in the form of objects carved in argillite, a soft black shale. Other groups soon followed the example of the Haida, though they usually made their works out of wood.

Today, Northwest Coast artists are still creating objects both for ceremonial use by their own

people and for sale to the outside world. The process is a circular one: the artist's grounding in the culture supplies energy and inspiration to create works for the art market, which is driven by aesthetics and style; at the same time, the art market is a competitive forum that, by its nature, continually challenges the artist and thereby contributes to the evolution of the artform, enriching the culture.

Nuu-chah-nulth artist Joe David points out, in a book called *A Haida Potlatch* by Ulli Steltzer, that "Change is inevitable and change is important . . . There is always somebody around saying you have to do things the old way . . . you have to be traditional. The fact is, there is always change and our people have always been comfortable with it."

It is not unusual for a gallery to essentially "lose" an artist for a period of months while he or she is fulfilling tribal obligations, but the artist's participation in those ceremonies will result in stronger work later. The reverse is also true. The cultural group will often "lose" the artist for periods of time to work on a gallery exhibition or a commission that will represent the culture on a national or international level, ultimately benefiting the culture. In addition, many of the artists contribute a significant percentage of their time, and/or the

income they derive from the making of their art, back into the culture, in terms of either political or cultural support, or both.

In the past, Northwest Coast culture was defined largely by artifacts housed in museums; but even when these pieces were first being collected in the late eighteenth century, there were some people who considered them to be works of art.

At the beginning of this century, a group of artists in Paris, including Picasso and Matisse, began to collect and be inspired by African sculpture. Their interest launched a reappraisal of so-called "primitive" art in general and in 1919 led to the first commercial exhibition of such art, in Paris. A year later there was another show at the Burlington Fine Arts Club in London, including a significant number of Northwest Coast items.

The first art exhibition devoted solely to Northwest Coast pieces was held in the mid-1920s by the Denver Art Museum in Colorado, followed in 1927 by an "Exhibition of Canadian West Coast Art, Native and Modern" at both the National Gallery and National Museum of Canada. In the 1930s there was a show of North American Indian art in New York and another in San Francisco as part of the 1939 Golden Gate Exposition.

This growing recognition of artifacts as art was

validated in 1941 when the Museum of Modern Art in New York held a historic exhibition titled "Indian Art of the United States," including a number of Northwest Coast pieces.

Two years later, in additional confirmation, Claude Levi-Strauss wrote an article called "The Art of the Northwest Coast at the American Museum of Natural History" for the *Gazette des beaux arts*: "Surely it will not be long before we see the collections from this part of the world [the Northwest Coast] moved from ethnographic to fine arts museums to take their just place amidst the antiquities of Egypt or Persia and the works of medieval Europe. For this art is not unequal to the greatest, and, in the course of the century and a half of its history that is known to us, it has shown evidence of a superior diversity and has demonstrated apparently inexhaustible talents for renewal."

No doubt inspired by the show at the Museum of Modern Art, some refugee Surrealist artists such as Max Ernst and André Breton started to collect Northwest Coast art. Young American artists of the Abstract Expressionist school such as David Smith, Mark Tobey and Barnett Newman were also excited by Northwest Coast art, and in 1946 they persuaded Betty Parsons to hold a show called "Northwest Coast Indian Painting" at her avant-garde gallery in New York. In the catalogue, Newman wrote: "There is an answer in these works to all those who assume that modern abstract art is the esoteric exercise of a snobbish elite, for among these peoples, abstract art was the normal, well-understood, dominant tradition."

In 1967 the Vancouver Art Gallery held an important exhibition titled "Arts of the Raven: Masterworks by the Northwest Coast Indian," a forerunner of many shows and books that testified to the recognition and popularity of the art.

The artists of the Northwest Coast have played an important part in the revitalization of their culture. Their study of the traditional artform and efforts to document its history sparked a rebirth of ceremony, with the attendant songs, dances and protocol, as they became aware of the connection between art and ceremony. Haida artist Reg Davidson confides in *A Haida Potlatch,* a book by Ulli Steltzer, that "The first Eagle headdress I carved didn't fit on anybody's head. It wasn't until I learned how to dance that I understood the art. Next time I did an Eagle headpiece, it had a purpose; it could fit on a person's head and be used for dancing. It wasn't heavy like the first one either."

The increase in cultural activity coincided with the political awakening of native peoples in Canada and around the world. From both outside the culture and, more importantly, from within, there was a strong perception that the culture was alive and growing and could survive culturally and politically. The major concern today of the Northwest Coast community is its continuation, recognizing the strengths of the past but determined to direct its own future.

As Haisla artist Lyle Wilson explains in his artist's statement in *UBC Museum of Anthropology Museum Note No. 28,* published in conjunction with his exhibition "Lyle Wilson: When Worlds Collide": "My works speak a visual language, one that I hope reflects my search for answers to the questions by all people seeking personal growth. Some of my work is called traditional and some more contemporary. These two labels are inadequate—perhaps irrelevant—in their description of the artistic process. I believe my best work takes account of the past, present, and future tense."

Those who collect Northwest Coast art today do so because they empathize with it on many levels. On one level, they are touched by and respond to the power of the work itself; on another level, they are giving implicit support to what the artists are striving for with their art and their cultural activity.

The artists of the Northwest Coast serve as ambassadors of a living and evolving culture, and their work speaks not only to audiences outside and within that culture but also to a deep inner core of feeling in all of us.

NORTHWEST COAST IMAGERY

The people of the Northwest Coast were essentially animist in their beliefs and considered that every living thing and natural element had a soul, a purpose, and was deserving of respect. Some of the images in their art were an acknowledgement of the power of the natural world of which they were a part. An example of the respect they had for the world around them and the consequence for those who violate this rule is the story of Volcano Woman. She destroyed an entire village to punish it for the wanton killing of a frog; it was considered acceptable for people to kill for food or clothing but not for the thrill of killing.

Art was an intrinsic part of all Northwest Coast cultures, a part of everyday as well as ceremonial life. "Art was one with the culture. Art was our only written language," is how Haida artist Robert Davidson explained it in the book *Robert Davidson: Eagle of the Dawn,* edited by Ian M. Thom.

As Northwest Coast societies had no written language, all cultural information was passed down through oral tradition and visual documents such as masks and totem poles.

The imagery used on masks and poles includes creatures from the natural world (Eagle, Killer Whale), natural elements and forces (Moon, Weather) and humans. Other images are manifestations of the spirit world; they represent supernatural beings.

Some creatures, like the Raven, belong to both the natural and spirit worlds. The Haida nation, for example, has many stories about Raven, a prominent supernatural being who could change form. Raven would appear in different villages in different guises—animal, human or bird—and, through his inherent curiosity or sense of mischief, alter the circumstances present in that village. Among other things, Raven brought light to the world and the idea of the house.

Many of these beings were adopted as crests, or symbols of identification, by clans or families or even individuals. The clan is a subdivision of the tribal group: the number of clans varies from tribe to tribe, and a clan will own a main crest and a number of subcrests. These clan crests such as Eagle or Raven serve as reminders of events in the history of the clan. Crests are associated with

stories owned by a clan or family; these often relate to the adventures of particular ancestors and describe how the rights to crests, names, songs and other privileges were obtained.

The display of crests on poles and on masks and regalia at public ceremonies confirmed ownership of them, defined the territory in which the crests were valid, and brought the power associated with the crests to life.

A family of the Eagle clan would draw on the powers of the Eagle, both in its natural and mythic sense, to define them as a group in relation to others. Robert Davidson tells a story that his grandmother told to him about a young man preparing for his initiation into manhood by fasting and purifying himself in the forest, in order to get in touch with those powers that would define his adult identity. Eventually he returns to the village and enters the ceremonial hall. He dons the spirit mask and performs the dance as it was revealed to him during his time in the forest and becomes human. When he finishes the dance and removes the mask, he is no longer a boy but instead is an adult.

MASKS AND CEREMONY

Masks are documents that embody tribal divisions

and mythology, as well as the rights of their owners. The rights to use particular masks are highly regarded; masks and crests are important pieces of property that can be acquired not only through inheritance and marriage within a tribe, but by marriage between members of neighbouring tribes. Sometimes masks were presented to a visiting chief who had earned the honour through good relations with the host of a feast or potlatch; the reasons for giving the mask were publicly stated at the time of presentation.

Masks are an important part of ceremonial life; they make the supernatural world visible and bring it to life in dance dramas. In the past, these were performed at feasts or as part of the complex ritual that has become known as the potlatch. They were also performed by dance societies during the winter, when bad weather made travel and hunting or fishing difficult, and people lived on the food that they had preserved by drying and smoking.

The term "potlatch" means "to give," which refers both to the giving of oneself as well as the giving of gifts. Feasts and potlatches are meetings of chiefs and high-ranking people of a tribe, brought together by an individual or family to witness its claims.

A traditional feast or potlatch lasted between several days and several months, depending on the size of the host family, the agenda and the time that had passed since the last one. They were winter events, and the preceding year or more was spent in securing enough provisions to feed the host village and the guests for the duration of the ceremonies and in amassing goods to give away as gifts in payment for witnessing the event. At the end, masks were sometimes burned in a display of wealth or to protect cultural information.

Today, the feast or potlatch has a much more compact schedule. The ceremonies now take place in a single evening or a weekend, but a modern feast or potlatch is still a major undertaking. The work of organization and preparation, to say nothing of the expense of food, gifts, and commissioning masks and other ceremonial pieces, is an indication of the continuing importance of the feast or potlatch in maintaining and defining Northwest Coast culture.

The invited audience is there to bear witness to particulars such as claims to the rank of chief, names, crests, property (masks, songs, stories and dances), and the rights to specific uses of territories (fishing rivers, berry patches), as well as to validate the transfer of rights by marriage or inheritance and to acknowledge deaths. All the names, crests,

rights and property being claimed are displayed or described, all the songs are sung, and all the masks are danced.

The guests are considered to be more than just an audience; by watching and acknowledging what each ceremony entails, they are participants and are rewarded. Each guest is "gifted" by the host family, and guests of high status are given elaborate and valuable gifts. By accepting the gifts, the guests understand that they may be called upon at some later date to restate the information that they have been paid to remember. The dancers who performed are also recompensed in some way or are fulfilling tribal obligations.

Other families are often honoured by the invitation of the host to dance their masks. This defines who they are in relation to the host and gives them the opportunity display their power and the skill of their artists.

In the past, winter was also the time for dance rituals, whose number and complexity varied from group to group; the Kwakwa̲ka'wakw had very theatrical presentations as well as an elaborate organization of dancing societies, whose leaders controlled the ceremonies, including the initiation of novices.

One important dancing society was the *hamatsa* (or cannibal), whose members performed a complex dance cycle that lasted four days. The dance used a large cast of characters to tell a story about a cannibal monster and his three attendant bird monsters who ate human flesh.

A second dance society was that of the War Spirit. This society's most dramatic character was a *tuxw'id*, a female warrior, who was killed and returned to life four days later. Ghost dancers wore masks representing skulls, which also referred to the themes of death and revival.

A third dance society was the Atlakam, which used up to forty masked dancers to tell a story that detailed the tribe's history and access to knowledge from the spirit world. This dance series also described the workings of the universe, with each character representing one component of the natural and spirit worlds. Performing this dance gave a shape and perspective to the unknown and provided a sense of the cosmic order. Different families had the rights to the masks used, thereby creating a dependence on the other families to supply the pieces of the puzzle to perform the dance. After the masks were used at four successive events, they were destroyed by burning and new ones were made.

The members of a fourth dancing society wore

masks representing family crest myths, of beings such as Ḵumugwe', chief of the undersea, or Thunderbird, or elements of nature such as the Moon, Earthquake and Weather.

Some of the oral histories and the masks that document them are accounts of shamanic experiences. Shamans had control over supernatural powers and could use these powers for good or evil. Shamanic power was not necessarily hereditary but could be gained by a person through direct contact with the supernatural.

There are also portrait-style masks that often represent the personal history, events or experience of the artists or the people who commissioned them.

The most elaborate masks are transformation masks. They are used to display the transition from one form to another, as told in myths, such as Wolf to Man, or Raven to Man, or Bear to Man. The transformation mask consists of a mask inside a mask. It is a dramatic device made possible by technical ingenuity, using hinges and string. At the high point of the dance, the dancer will tug on strings that pull apart sections of the outer mask to reveal the one inside.

The dancing of a mask is a serious matter. In the past, an error or accident in the performance was a serious breach of protocol that might have a devastating effect on the dancer, artist or even the entire village.

The myths and stories associated with masks and crests all have numerous, sometimes very different, versions that serve to delineate distinctions between tribes, as well as between villages of the same cultural group. Nuu-chah-nulth artist Joe David explains: "Take, for instance, a carver's brief description of a character, any character, say Wild Man. Each Wild Man has a distinct personality and, in fact, because of the depth of his spirituality, has a very multidimensional personality, a very rich and broad personality. A person could live to be very old and hear many, many stories and attributes of Wild Man. So to simply say a mask is Wild Man of the Woods is basically meaningless."

The artist who creates or is commissioned to produce a mask knows that each being is defined by certain stylistic traits, though innovation and creativity are encouraged. Since the artist understands the necessity of representing both the external appearance of the character as well as its internal spiritual force, new interpretations of the character revitalize the image from within.

NARRATIVE MASKS

NARRATIVE MASKS HAVE STORIES OR SONGS ASSOCIATED WITH THEM THAT

DOCUMENT HISTORICAL AND PERSONAL EVENTS. THESE STORIES AND SONGS ARE

PASSED DOWN THROUGH FAMILIES OR THE MEMBERS OF SECRET SOCIETIES BY ORAL

TRADITION, AND SOME ARE NOT ALLOWED TO BE WRITTEN DOWN OR TOLD TO

OUTSIDERS. THE OWNERSHIP OF MASKS—WHETHER BY INDIVIDUALS, FAMILIES,

SECRET SOCIETIES OR CLANS—ENTAILS THE CEREMONIAL RESPONSIBILITY TO

CONTINUE TO DANCE THEM, TO TELL THEIR STORIES AND TO SING THEIR SONGS.

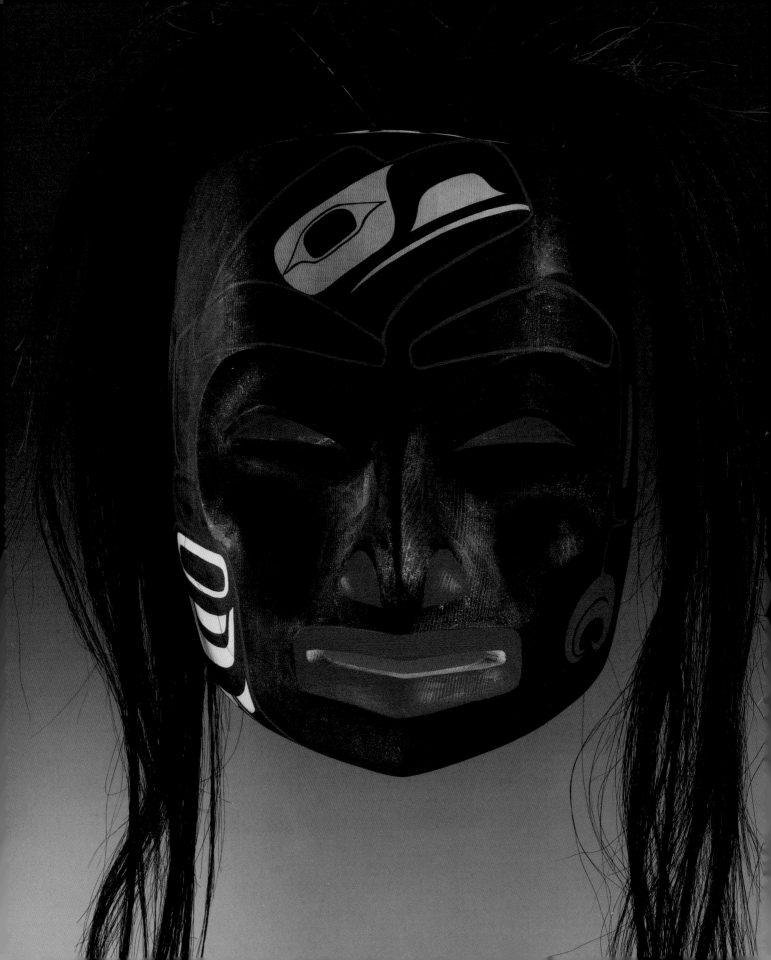

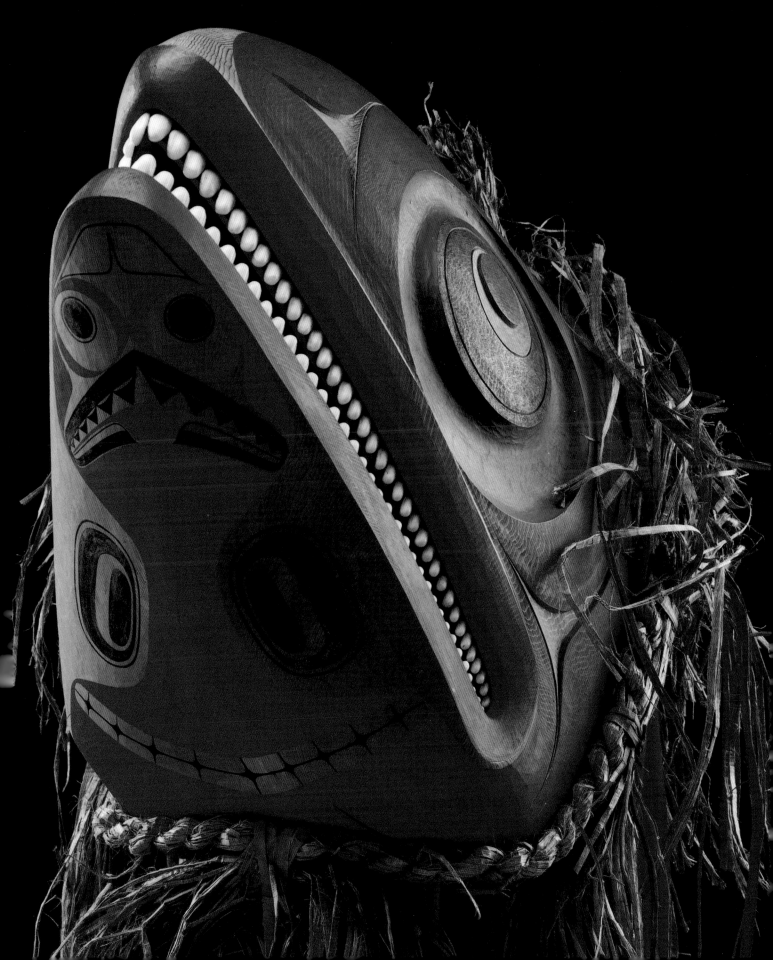

EVERY YEAR THE SALMON COME BACK

ROBERT DAVIDSON

(HAIDA)

RED CEDAR, CEDAR BARK, OPERCULUM
SHELL, CLOTH, GRAPHITE, PAINT
24" X 28" X 12" (EXCLUDING CAPE OF CEDAR BARK
AND CLOTH) (1989)

BLIND HALIBUT FISHERMAN

REG DAVIDSON

(HAIDA)

RED CEDAR, HORSEHAIR, GRAPHITE, PAINT
12" X 9" X 6.5" (1989)

On the forehead of this mask is the Raven. On the right cheek is the Raven's wing, and on the left is the Raven's claw, which is also a halibut hook. In Haida mythology, the Raven is known as the trickster, and there are many stories about how he earned this reputation. One is about the blind halibut fisherman, and there are many representations of this story on totem poles and other Haida sculptures. Often Raven is portrayed as part human.

One day, Raven saw a blind fisherman fishing for halibut. Raven saw this as an opportunity to tease the fisherman. He dove underwater and began to play with the fisherman's hook to make him think that he had a fish on the line.

Raven eventually became careless while playing this game, and the fisherman snagged his beak and pulled it off. When the fisherman pulled the beak into the boat, he realized what had been happening. The fisherman returned to shore but sensed that Raven was following him, mourning for his beak. The fisherman tossed the beak into the air, but Raven misjudged his position and the beak stuck to his chin.

I have returned often to fish at the Yakoun River near my home village of Massett on the Queen Charlotte Islands. This is a place that has never changed, and when I fish there, I am reminded of my ancestral past, and I think about the salmon, the birds, the trees and the importance of our interconnectedness. I wanted to make a visual connection between the salmon cycle and the human cycle, as we are becoming less and less aware of where things come from. This mask is a reminder of the source, like saying grace before a meal.

This mask was carved and first used in 1989 at a feast in Massett titled "Every Year the Salmon Come Back."

The purpose of this event was to demonstrate another level of understanding, a level which our ancestors knew. The feast was also a forum for cultural responsibilities. I often heard people say "I would love to sing if only I had a drum," so I gave drums as gifts, as a way of giving cultural responsibility to those willing to accept it.

The carving of the mask, and the dancing and ceremony, were another way of giving back. This mask has been danced numerous times since, although we (the Rainbow Creek Dancers) are very selective about where we show our dances. This mask has been growing in meaning.

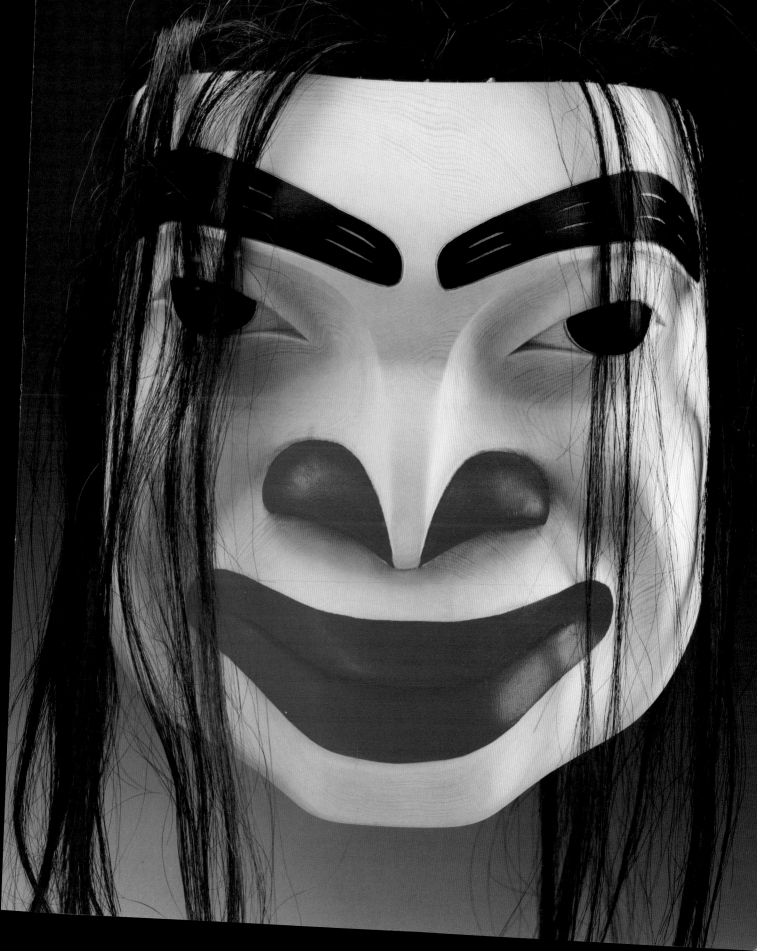

PORTRAIT MASK

STAN BEVAN

(TAHLTAN/TLINGIT/TSIMSHIAN)

ALDER, HUMAN HAIR, PAINT

8.5" X 7" X 4" (1989)

Portrait masks depict the features of people and are used in narratives about people both past and present.

This mask is carved in the Tlingit style, which is characterized by wide features and a bold expression. My personal style is a mixture of both Tsimshian and Tlingit influences, as well as traits that are personal to my own carving style. Both of these tribal styles offer strengths as well as limitless possibilities. The exploration of a particular tribal style is always affected by the steps taken by the carver looking and reaching for a new level.

HAMATSA RAVEN

BRUCE ALFRED

(KWAKWA̲KA̲'WA̲KW)

RED CEDAR, CEDAR BARK, FEATHERS, PAINT

12.5" X 58" X 9 (1989)

The Raven has a prominent place in the mythology and art of the Kwakwa̲ka 'wakw people. Raven is a servant of the spirit known as Baxwbak-walanuxwsiwe', who lives in a big house at the north end of the world. The Raven is one of three cannibal birds that can be shown in the *hamatsa* (or cannibal) dance, and it is always used, even if just one mask is being shown. When Raven is particularized in a *hamatsa* song, the initiate goes wild and loses control until after the song and dance are over.

The Raven mask, along with its birdlike features, has flared nostrils and staring eyes. A large cedar bark mane flows over the dancer, disguising his shape. The early masks of this character were painted black with white eye sockets and red lips and nostrils. This evolved to a more elaborate red and black formline over a white base, and while this is still done today, many other colours and stylistic features have been added.

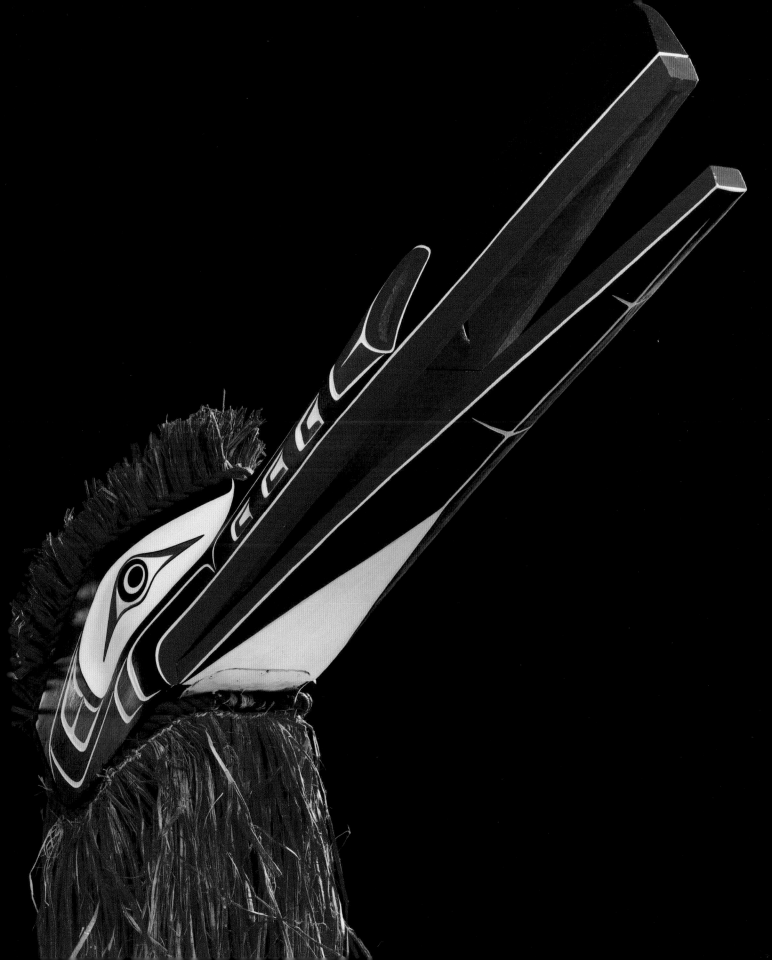

RAVEN AND THE LIGHT

LYLE WILSON
(HAISLA)
YELLOW CEDAR, ABALONE SHELL, PAINT
23" X 21" X 12" (1992)

There are many ways to portray the story of Raven and the light. Sometimes the light is the sun and other times the moon. On a deeper level, the light represents the first consciousness of human thought. In one version, Raven was originally white. He schemed to get a great ball of light which an old, ill-humoured chief possessed. The daughter of this chief drank regularly from a certain well of cold clear water, so Raven changed himself into a pine needle, which she drank along with her water. In due course, Raven, in the form of a small boy, was born to this woman.

Like all small grandsons, he won the old man's heart, simply by being young, mischievous and full of life.

This suited Raven, since he was naturally self-centred, loud and mischievous. Raven pretended that he wanted to play with the light, and like the spoiled rotten child he was, he yelled, screamed and cried, until the old man let him play with it.

Suddenly, Raven transformed into his true form and, snatching the ball of light in his beak, flew out through the smoke hole. He turned black from the soot and smoke. The ball of light was too heavy to fly with, so he ran through the forest. Just as the old man was about to catch him, Raven threw the ball of light into the sky. The old man could only watch as his greatest treasure astonished the creatures of the world with the gift of light.

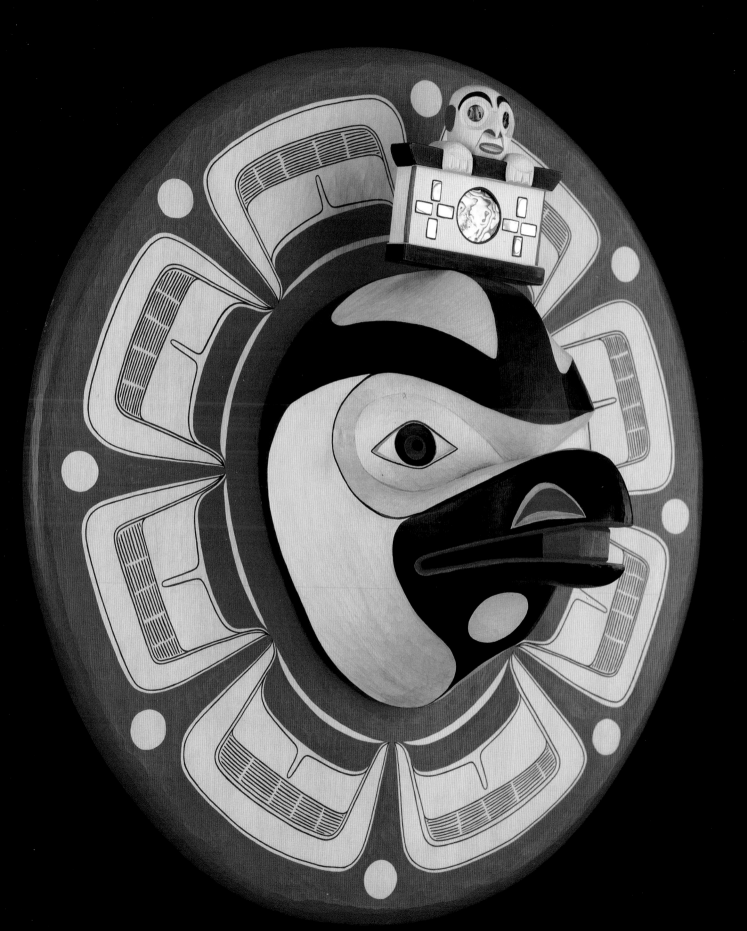

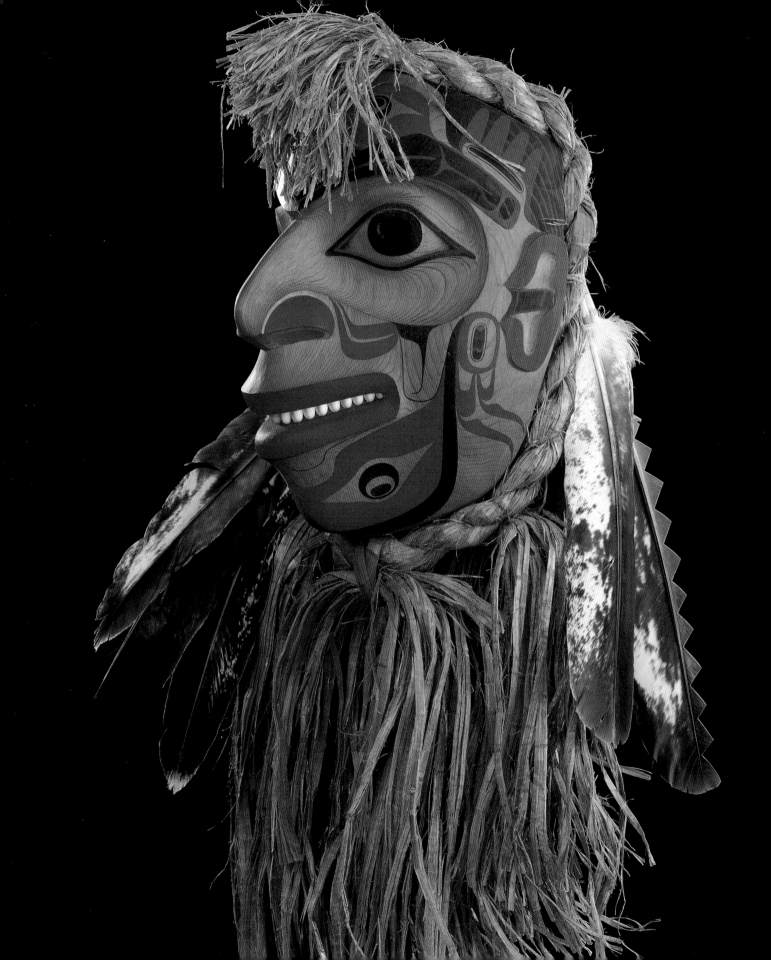

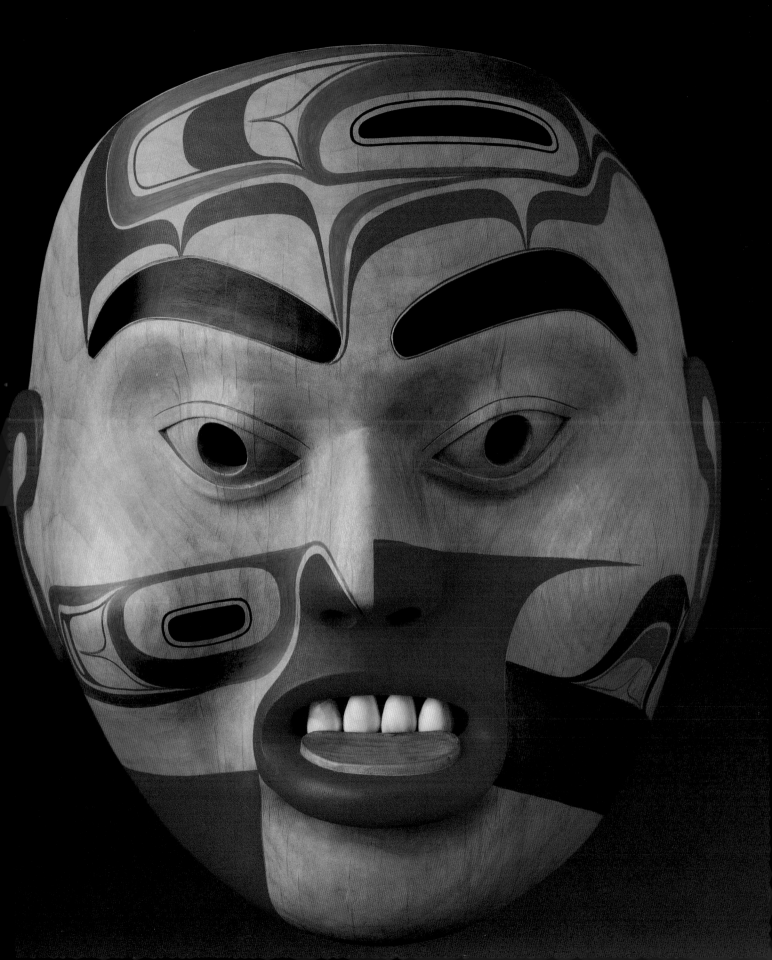

NOBLEWOMAN

JOE DAVID
(NUU-CHAH-NULTH, CLAYOQUOT)
HAIDA STYLE
ALDER, OPERCULUM SHELL, PAINT
11" X 9" X 5.5 (1992)

HE WHO HAS SEEN THE SPIRIT

ROBERT DAVIDSON
(HAIDA)
RED CEDAR, CEDAR BARK,
OPERCULUM SHELL, FEATHERS, PAINT
13" X 9" X 7.5" (1990)

What is missing in our lives is initiation or the acknowledgement of moving into the next stage of life, like childhood into manhood. In the past, these occasions were respected and nurtured. I carved this mask with the strength being gained by our people in mind. There are things in our lives which we can postpone but cannot deny forever. There are also things that we must confront or they will continue to confront us until we finally are able to deal with them. This is myself coming to terms with myself.

I am often asked to describe a piece because people expect me to have a clear vision and historical reference before starting a work, and they are disappointed when I answer "I don't know what it means." I have become comfortable with this answer, as I now know that answers are revealed in good time. This was probably equally so in the past, although the answer may have been better understood. In this book is a mask titled Crab of the Woods, which is a very serious mask for me. He Who Has Seen the Spirit became its counterbalance, where my spirits were lifted. It is a mask about carrying on.

This is carved in an older Haida style and represents someone very special at the time. Masks of such people were commonly shown at ceremonies after they had passed away to acknowledge their importance and to keep their presence at such events alive.

Masks such as these were also carved as trade or curiosity items, obviously because traders were attracted to the images. Many of these were not real masks because little wood was taken out of the back so they could not be worn, but they are still very powerful pieces.

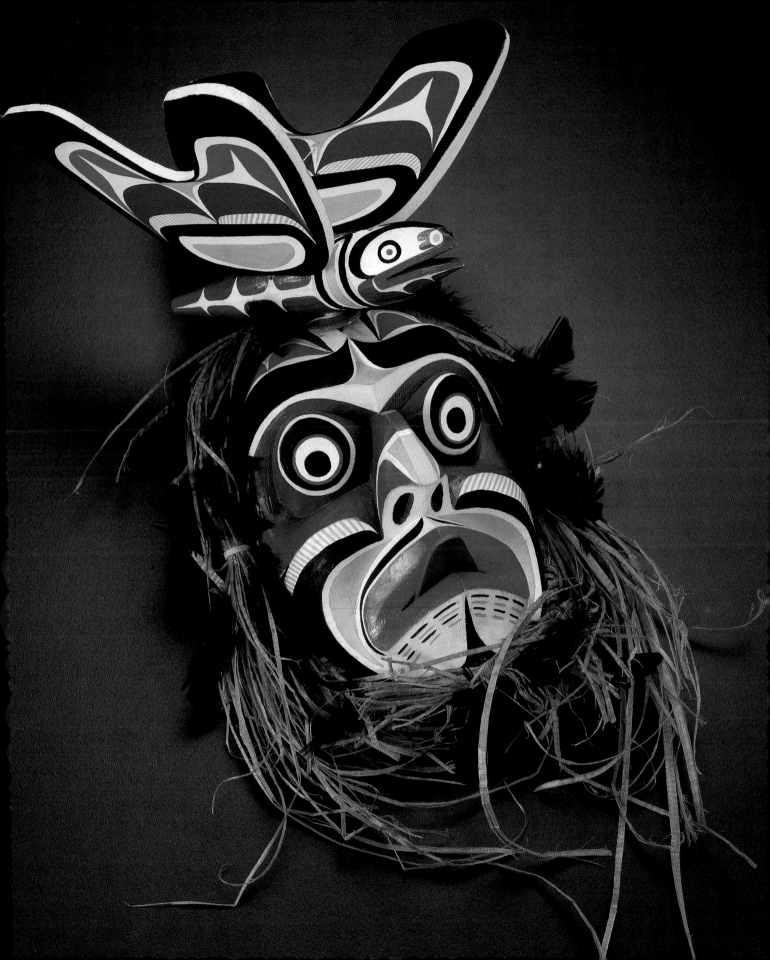

NOOMIS

WAYNE ALFRED

(KWAKWAKA'WAKW, NIMPKISH)

YELLOW CEDAR, YEW, CEDAR BARK, TWINE, PAINT

13" HIGH (8" X 6" WITH WINGS EXTENDED) (1987)

Noomis is a survivor of the great flood. There are many stories of the great flood which covered the coast. Noomis climbed a great mountain and the water rose to above his neck. A butterfly landed on his head and befriended him. The butterfly returned with food and told Noomis secrets about how to live after the water receded.

Noomis is danced as an ancestor who is as old as time itself. He crosses the room slowly and lights the fire by poking at it. His mask is a treasured property that is handed down through families.

WARRIOR

KEN MCNEIL

(TAHLTAN/TLINGIT/NISGA'A)

ALDER, HUMAN HAIR, PAINT

11" X 9" X 6.5" (1989)

The Warrior mask documents heroes and victims of great battles. This mask is the result of experiments I have been doing with different shapes and forms of the human face. I studied older pieces to see what had been done and searched for what could possibly be explored further.

Keeping that in mind, I also studied people and their features and expressions. Our people are our art, and the art comes from our people. This Warrior mask is both portraiture and drama, depicting someone who earned his place in legend through battle.

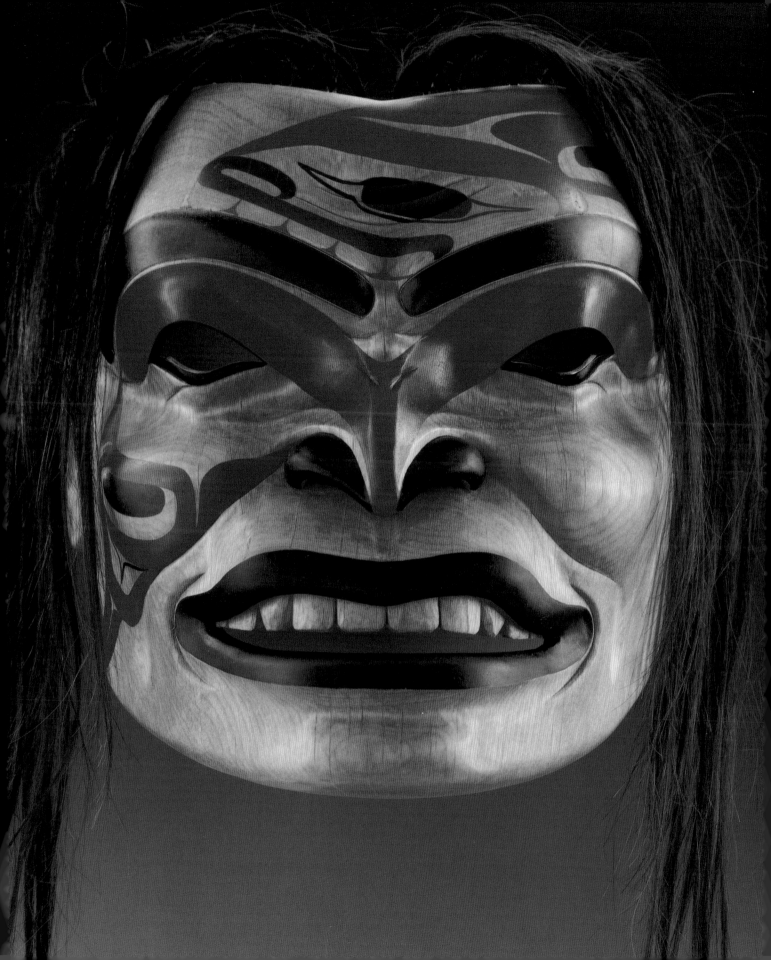

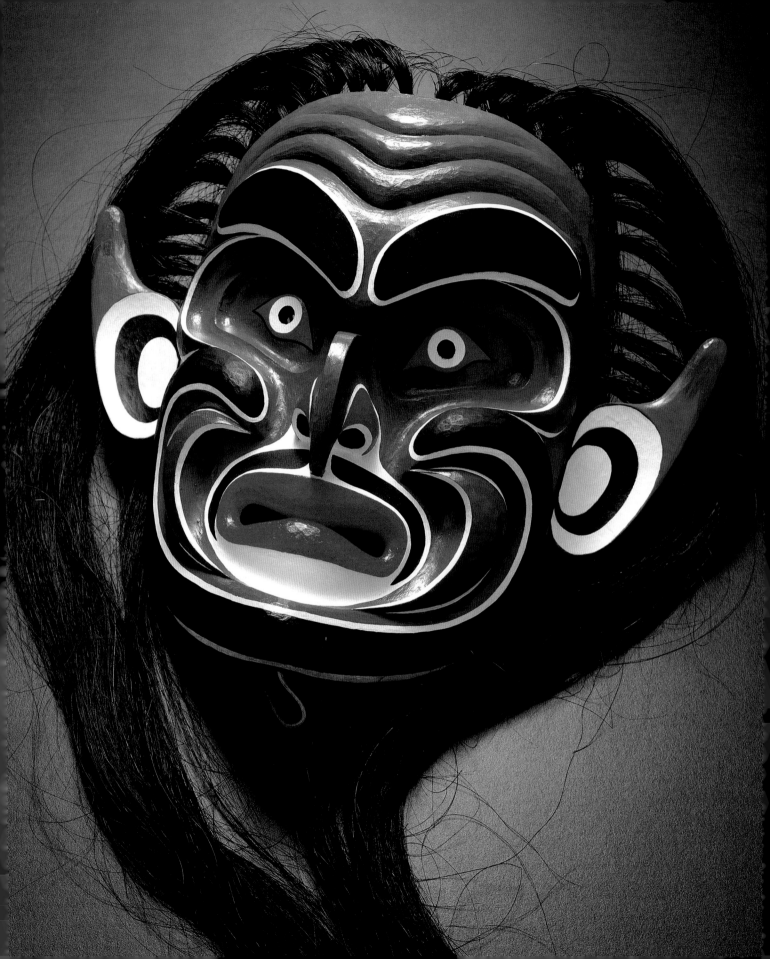

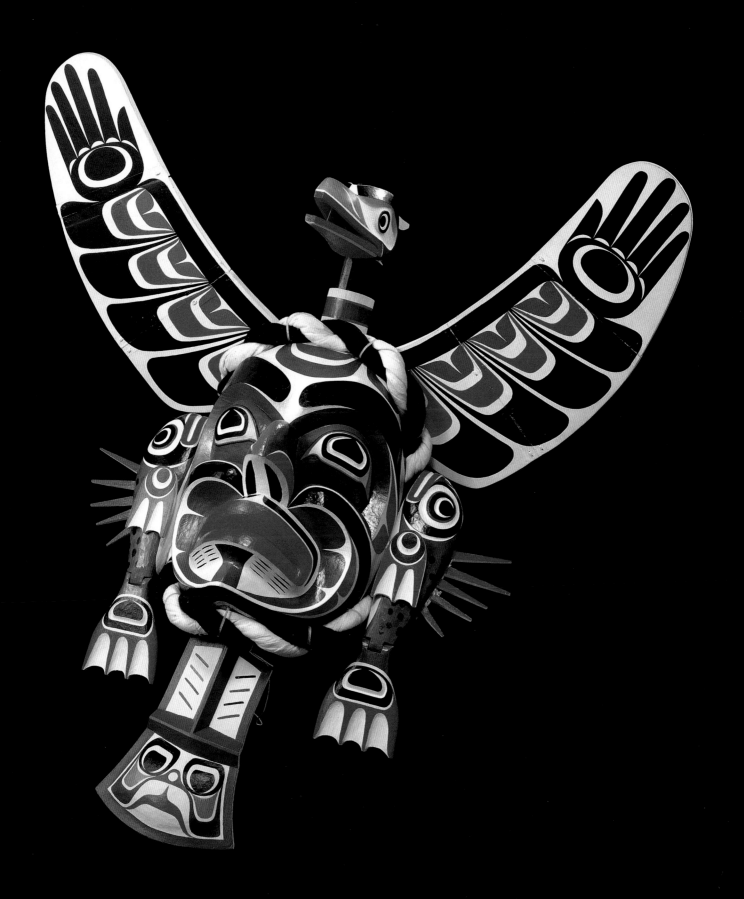

K̓UMUGWE'

WAYNE ALFRED
(KWAKWA̲KA'WAKW, NIMPKISH)
RED CEDAR, TWINE, PAINT
34" X 39.5" X 13" (1987)

BA̲K̓WAS

BEAU DICK
(KWAKWA̲KA'WAKW)
RED CEDAR, HORSEHAIR, PAINT
12" X 13" X 6" (1987)

The *ba̲k̓was* (wild man) is the spiritual embodiment of everything in the forest. Although it is represented as being of human size in the dance, in reality it is the size of a leprechaun. To see a real *ba̲k̓was* is rare. If you stare too long at it, it will entice you into his world by offering you his food.

The *ba̲k̓was* is known to eat snakes, snails, slugs, etc., although his favourite is cockleshells, which many common people avoid for fear of being taken to the ghost world.

Ba̲k̓was was carved either with deeply recessed eyes, linear skeletal marks on the forehead and cheeks and pointed ears, or with nearly human features. Stylistic differences were due to artistic interpretations and the characteristics of the particular *ba̲k̓was*. There are many versions of the *ba̲k̓was* story and the performance also varied from village to village. The rights to *ba̲k̓was* were handed down through the lineage of the owner. In my family, these rights were held by my father.

There are many stories about K̓umugwe'. My version comes from the legend of Siwidi. When it was time to assume his position as chief, Siwidi was still very young and lacked the necessary skills of leadership. His uncle and cousins tricked him, because his uncle wanted his position. They promised to take him seal hunting and lured him to an island, where they brutally beat him and left him for dead. Siwidi lay on the rock unable to move, listening to the water which he heard splashing in a nearby tide pool and mistook for laughter at his misfortune. He felt himself being transported to the bottom of the ocean, where he entered the domain of K̓umugwe', the chief of the undersea world.

Siwidi was adopted by K̓umugwe' and spent several years living in his domain until he felt a need to return to his home village. He was granted this privilege by K̓umugwe' and was given the rights to the dances, masks, and songs of the undersea kingdom, which became the source of his power.

K̓umugwe' is often represented with a loon on his head, in reference to the story of a loon mistaking him for an island because of his great size; his movements cause tides and whirlpools. This style of K̓umugwe' mask was used by my father at a potlatch in 1981.

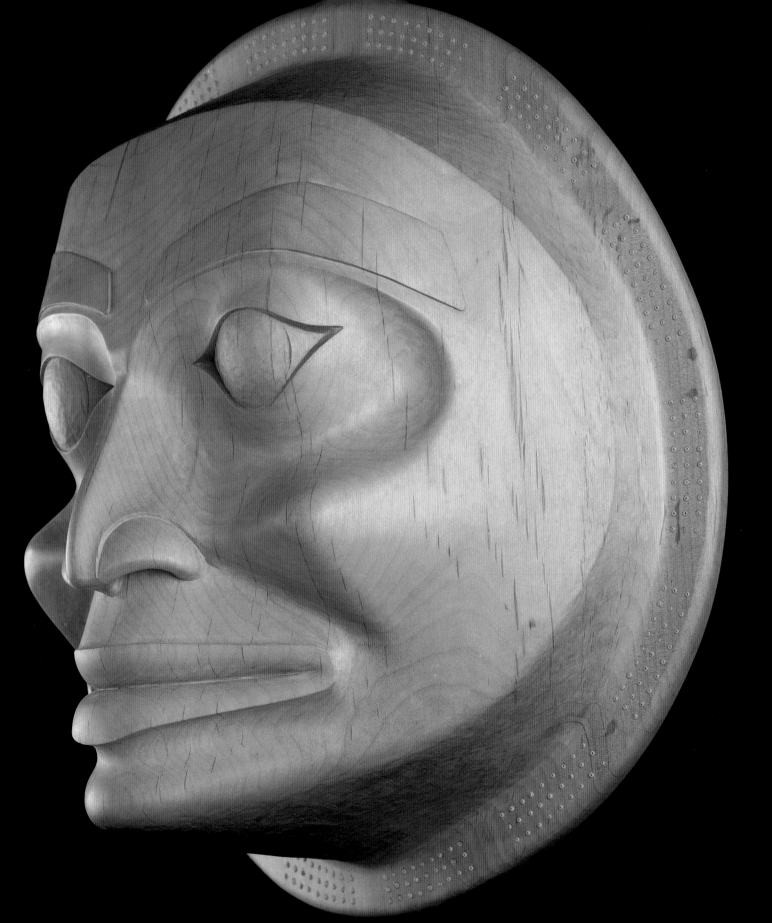

RICH MOON MASK

NORMAN TAIT

(NISGA'A)

ALDER, BEADS

15" X 13.5" X 9" (1991)

The Moon is so much a part of our stories that a story will usually begin with the words "On the Moon before the eulachon" or "On the Moon that I was born" or "On the Moon that your grandfather left us," and continue from that point.

The Moon is such a powerful force and symbol that no person can claim it as a crest or otherwise: it is shared by everyone.

The Moon is the symbol of ultimate power. There are two types of Moon, "The Moon" and "The Rich Moon." The ordinary person would use a plain Moon face in his stories and carve a plain Moon face, but a person of status would decorate a Moon face with abalone, mirror, gold, silver, beads, etc. to indicate his position in society.

HOW HOW MASK

MARVEN TALLIO

(NUXALK)

RED CEDAR, CEDAR BARK, PAINT

18" X 39" X 10" (1989)

The How How is the second of three cannibal birds danced as part of the *kusiut* (secret society rituals). The stories of the origins and use of these masks remain within the oral traditions of the secret societies. The cannibal birds are supernatural forces who were defeated in historic battles.

A short version of the legend tells of the first sighting of the cannibal birds by four brothers who were hunting goats on a mountain in Bella Coola. The brothers bedded down for the night, but only one brother planted a staff between his feet to spiritually connect him to the mountain goats. He awoke in the middle of the night to witness the killing of his three brothers by a large cannibal bird. At first he saw only one of these birds. He drew his bow and shot an arrow over the fire, killing the bird, but more appeared, so he continued to fire arrows through the night. In the morning light he saw that he had killed many of these great birds. He burned their remains and watched as the sparks transformed into mosquitoes.

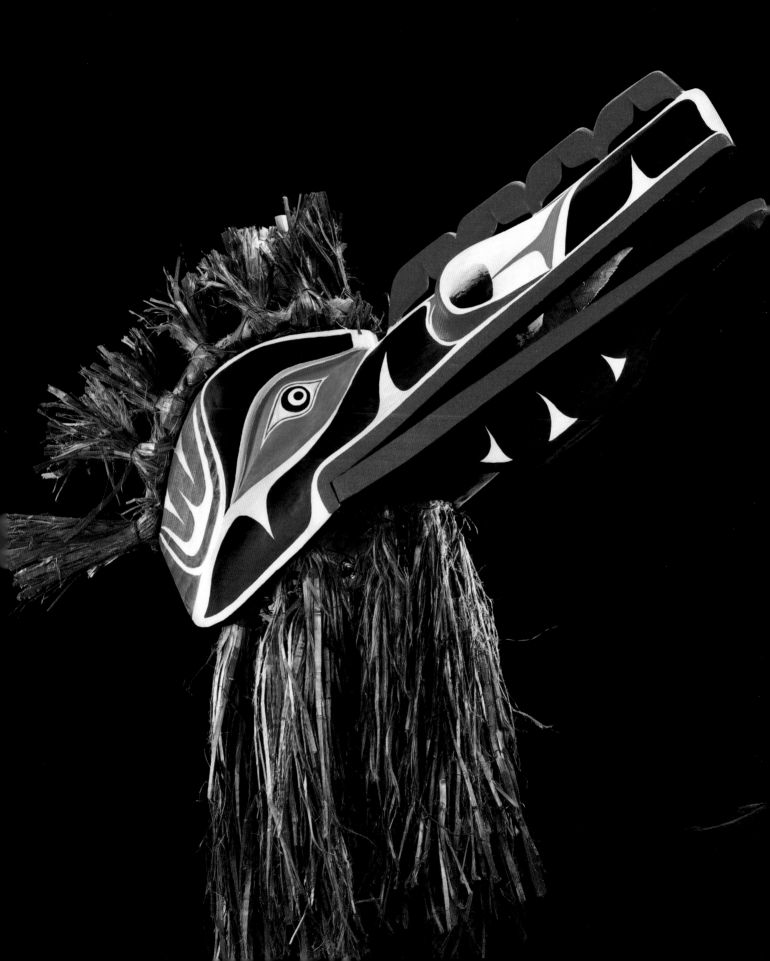

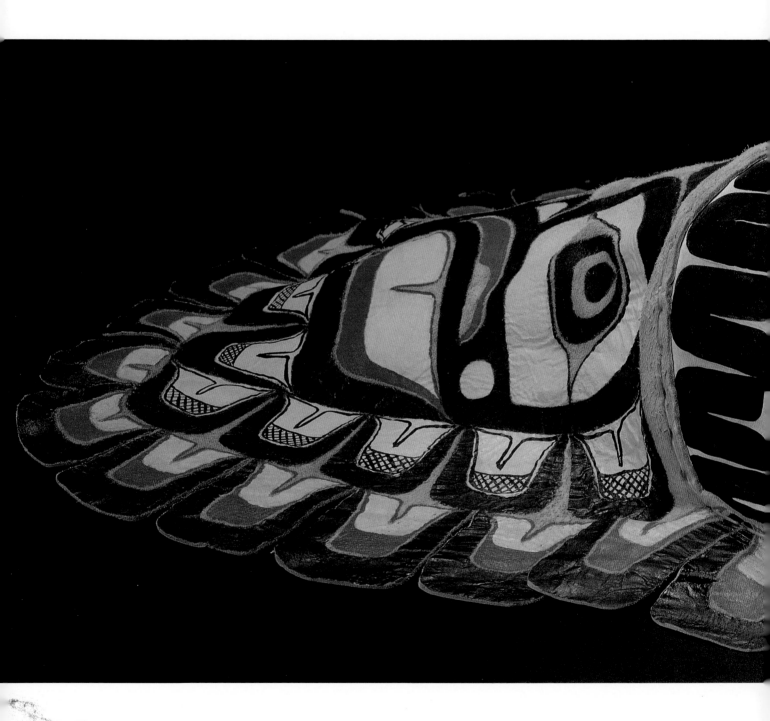

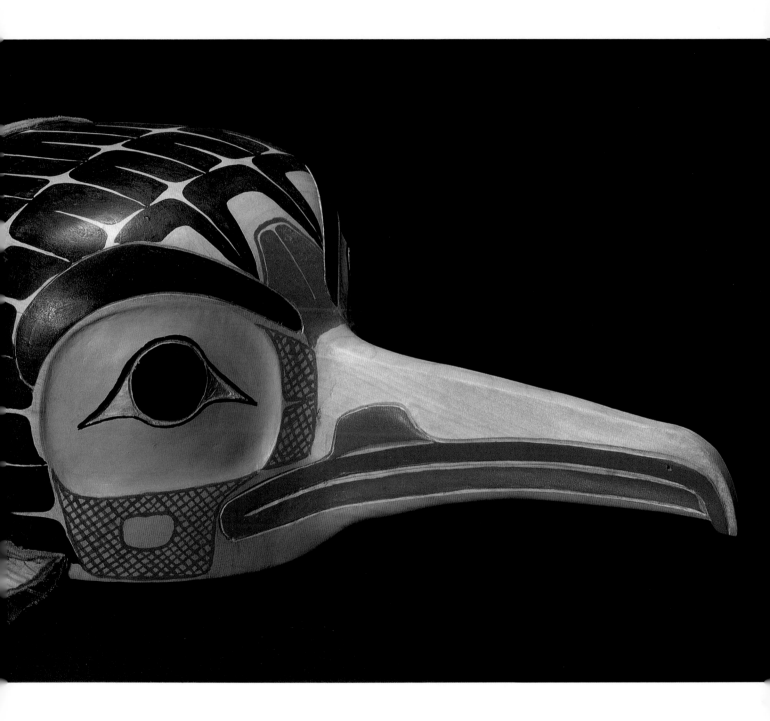

CORMORANT HEADDRESS

FREDA DIESING

(HAIDA)

ALDER, LEATHER, PAINT

8" X 14" X 8"

(WITH A 13" LEATHER CAPE) (1987)

The Haida have groups of stories that flow together, emphasizing rules to live by in the context of describing history and families. I was attracted to the story about Volcano Woman because I am Haida but have lived most of my life among the Tsimshian, and it describes the historical relationship between these two groups.

In the story, a boy puts on a Cormorant headdress, which he should not wear as it is not his crest. He allows the headdress to slip from his head and fall into the water. This is disrespectful to the families who own the Cormorant crest. The story of the headdress gives insight into the personality of a group of boys who kill a frog for no reason. The frog was a child of Volcano Woman, who tells the boys that only one of them will reach home, bearing the news that the village will be destroyed for their actions.

One woman survives the destruction of the village by a great volcano. She marries a Tsimshian man, who takes her from Haida Gwaii to the mainland. She eventually returns home, although her children, who are descendants of this particular Eagle family, live on both the mainland and Haida Gwaii.

This story is about respect for nature and the feelings of others. The original Cormorant headdress was probably the skin of a real cormorant, but being a carver I chose to carve it. I have never seen a Cormorant headdress, so I wanted to make one.

TUXW'ID

BEAU DICK

(KWAKWAKA'WAKW)

ALDER, HORSEHAIR, PAINT

11" X 7" X 8" (1987)

A *kominicka*, also referred to as a *tuxw'id* (female warrior), is the highest-ranking person in the War Spirit dancing society. The *tuxw'id* dance displayed some of the most complex theatrical innovations on the Northwest Coast. The re-enactment of the *tuxw'id*'s public decapitation and return to life four days later demanded realistic props and perfect theatrical execution by all participants. In between the decapitation and return to life, her severed head was on display for four days. She has numerous ways of demonstrating her power.

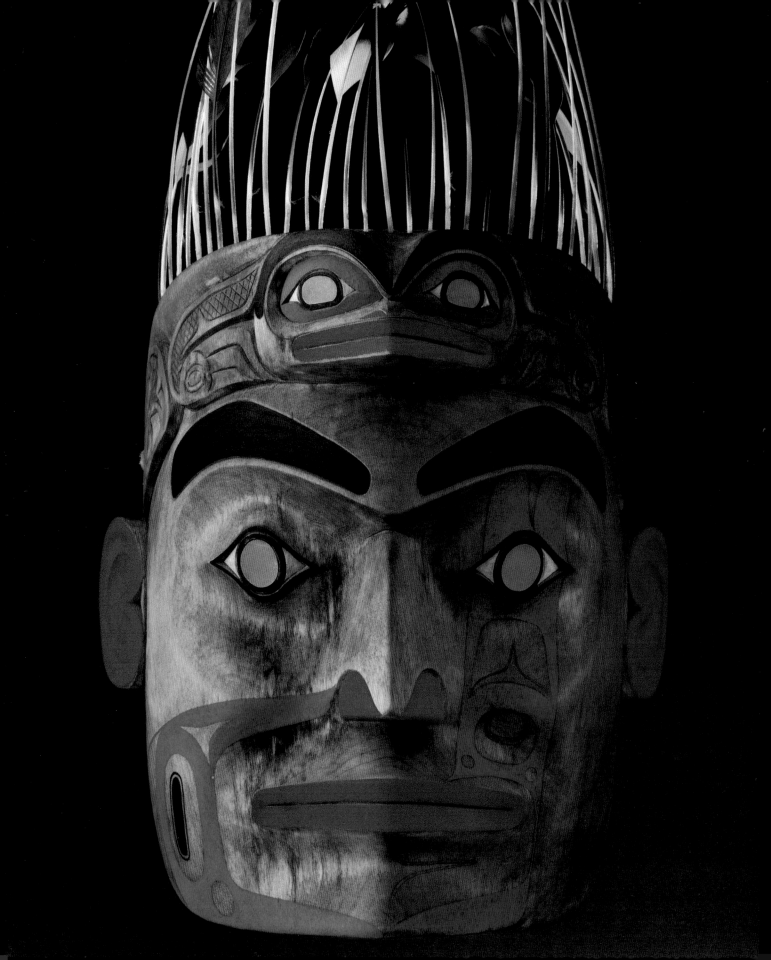

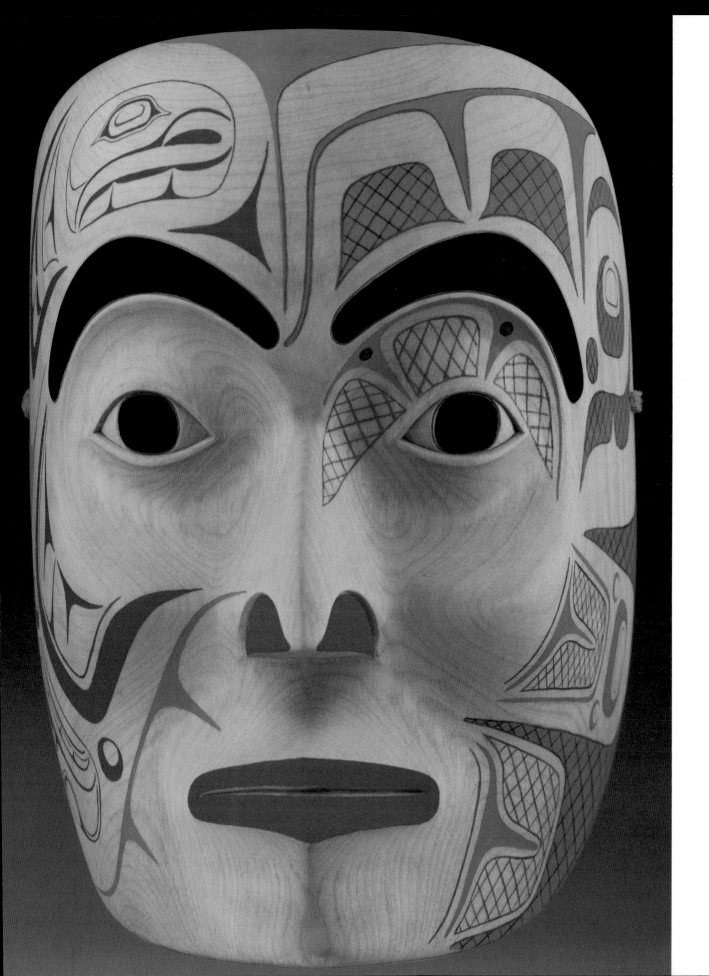

SIM'OOGIT

ROBERT JACKSON

(GITKSAN)

SILVER BIRCH, COPPER, FEATHERS,
SEA LION WHISKERS, PAINT
13" X 9" X 5" (1989)

DAYDREAMER

ROBERT JACKSON

(GITKSAN)

SILVER BIRCH, PAINT
13" X 9" X 5" (1989)

WARRIOR

JOE DAVID

(NUU-CHAH-NULTH, CLAYOQUOT)

ALDER, HORSEHAIR, PAINT
10" X 8" X 5" (1987)

The term *sim'oogit* means "chief," and these two masks are a part of a specific legend documenting this chief and his wife, Daydreamer. The story is part of the oral tradition of my family and must not be written down.

Portrait masks are among the most difficult ones to carve because they must look like real faces. The expression and characteristics of the face may be documented in the masks used by previous generations, and these must be translated into the style of the contemporary artist. The features and expression of the mask must suit the character of the person or being, and the design must also compliment the features. When carving masks for two characters who are part of the same story, the masks must be compatible.

These two masks are contemporary in style but traditional in form and colour. Traditionally, the designs on Gitksan portrait masks were painted on rather than carved and were used to highlight the carving or to break up the contours.

This mask represents a great warrior. Many of the older warrior masks were used as teaching tools for young warriors.

PAGE 34
SIM'OOGIT

PAGE 35
DAYDREAMER

WARRIOR

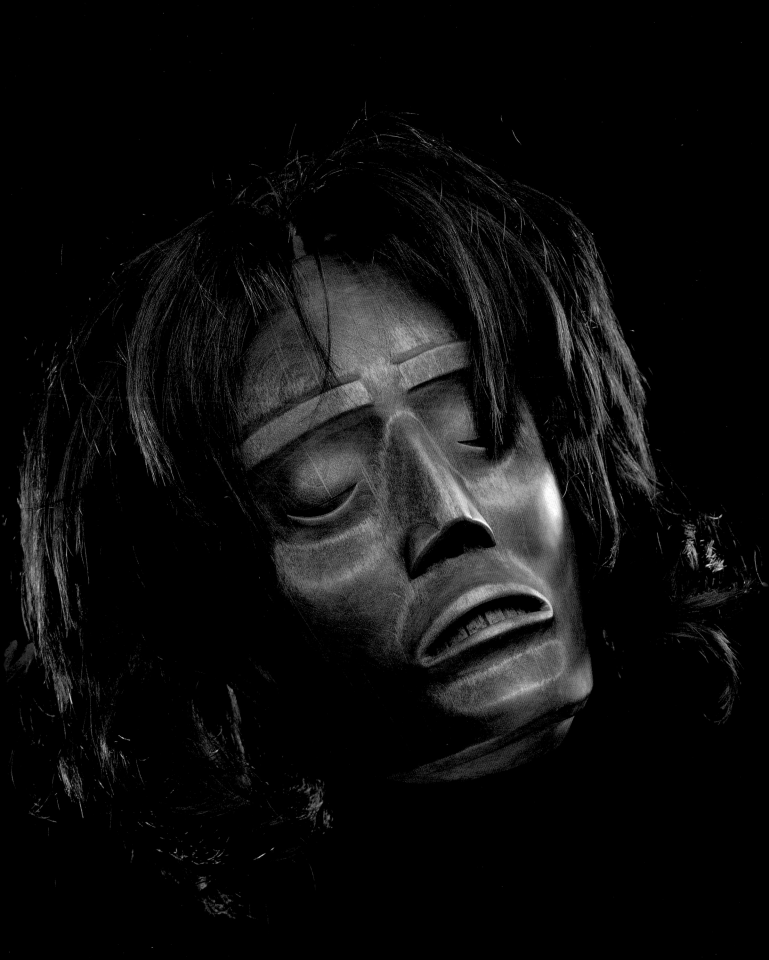

THUNDER SPIRIT MASK

GLENN TALLIO
(NUXALK)
RED CEDAR, CEDAR BARK,
COCONUT PALM STEMS, DOWN, PAINT
12" X 10.5" X 10.5" (EXCLUDING CEDAR BARK CAPE
AND FEATHERS) (1989)

Two major dance rituals make up our winter dance ceremonies, the *sisaok* (ancestral family dances) and the *kusiut* (secret society ceremonies). This is one of our masks used in the *kusiut* ritual. The Thunder Spirit is powerful and feared.

All *sisaok* masks are introduced so that the owner and/or the source of the mask's name and the mask itself are acknowledged. Numerous dances lead up to the Thunder dance, which is introduced and narrated by a female speaker wearing a mask and blanket. She introduces a herald who is also wearing a blanket and mask, but in a different style. The herald carries a large staff and announces the impending Thunder dance and storm. Often two jesters will appear after each different mask dance and mimic their movements and echo their sounds or announcements.

Once there were four Thunder masks representing four brothers who had historic battles over control of the Thunderstick. The Thunderstick is represented by an intricately carved receptacle filled with cedar bark cinders from the fire. In the end, all four shared control over the use of the stick. Our community of Bella Coola rests in a valley between four mountain peaks which are the domain of the four Thunderbirds.

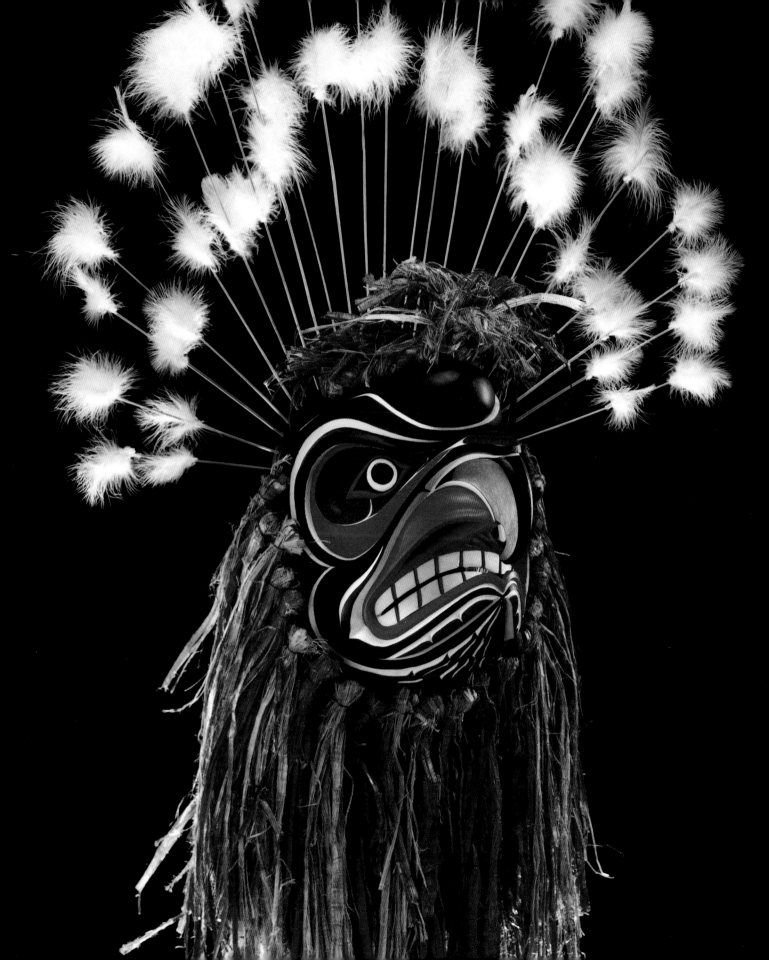

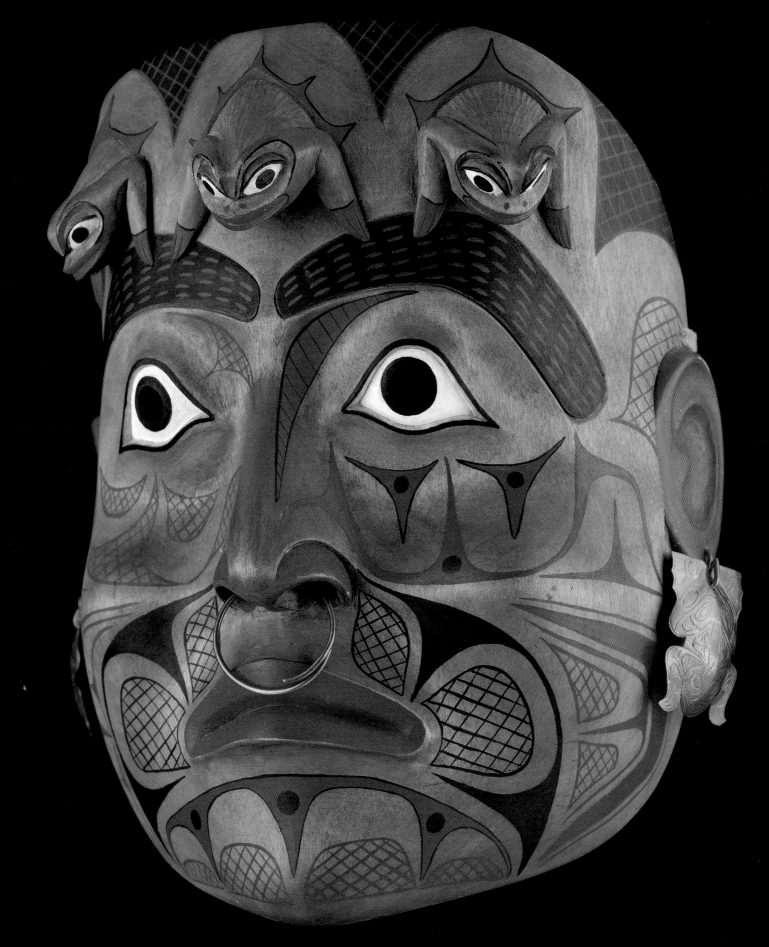

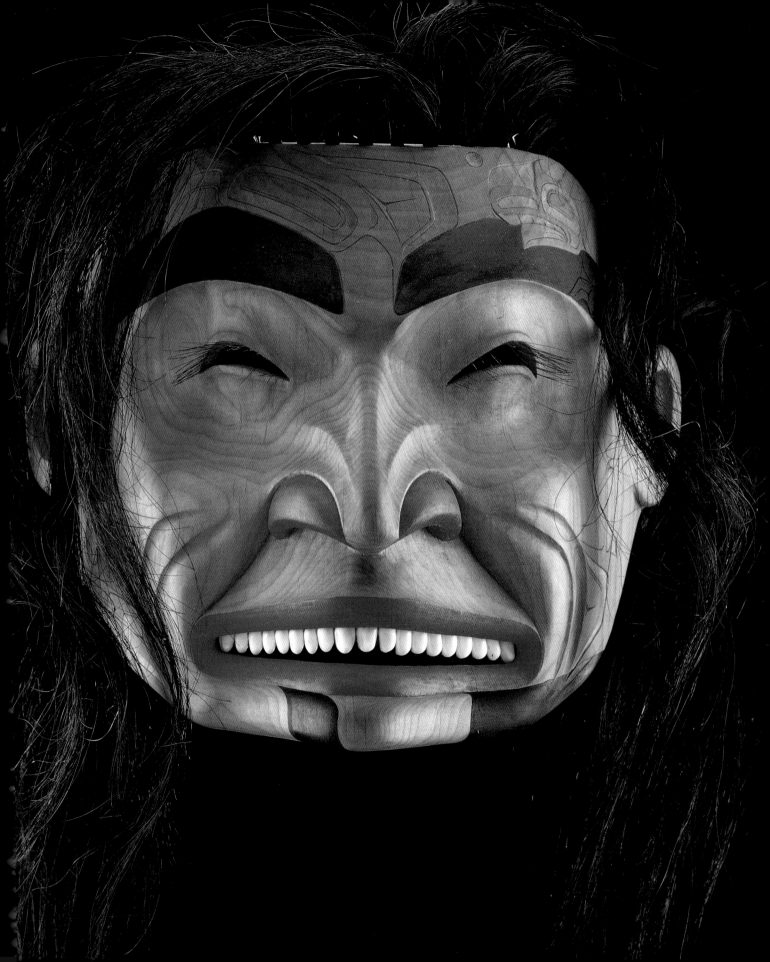

SPIRIT WHO CONTROLS
THE WEATHER

NORMAN TAIT
(NISGA'A)
ALDER, HORSEHAIR, OPERCULUM SHELL, PAINT
11" X 13" X 9" (1989)

PRINCE OF FROGS
ROBERT JACKSON
(GITKSAN)
SILVER BIRCH, COPPER, PAINT
10" X 8" X 4" (1988)

The Prince of Frogs mask is based on a character rather than a story. There are numerous stories about the Frog, or people of the Frog clan, although this mask is not specific to any one of these. The figures across the top are the Frog children.

I prefer to carve masks that are contemporary in style, because then my imagination can run free. Traditional masks require a stricter form, both in design and carving; certain rules must be followed.

In some cases, like this one, where I base a mask on a character in a story instead of on the story, I carve a mask that depicts a particular character in the manner that I feel the character should look, rather than the way it did look traditionally. If the mask requires liberty in design and form and colour, I will give it what it needs. The depiction of a character will vary from generation to generation, depending on the styles of individual artists.

A mask may be beautiful to look at, but it is the dancer who brings it to life while acting out its character. In most cases, the song that is sung while a dancer is performing with a mask tells the story about the mask.

The Spirit Who Controls the Weather is one of the few spirits from whom the ordinary person can ask favours. Because the weather can change quickly at any time, our people believe that a mischievous spirit is behind it all. So before a fisherman or hunter or traveller starts off in his canoe, he usually asks this spirit to give him good weather. If he is caught in bad weather, he believes that he has wronged the spirit and asks for forgiveness. If he curses this spirit, then he is sure to be caught again.

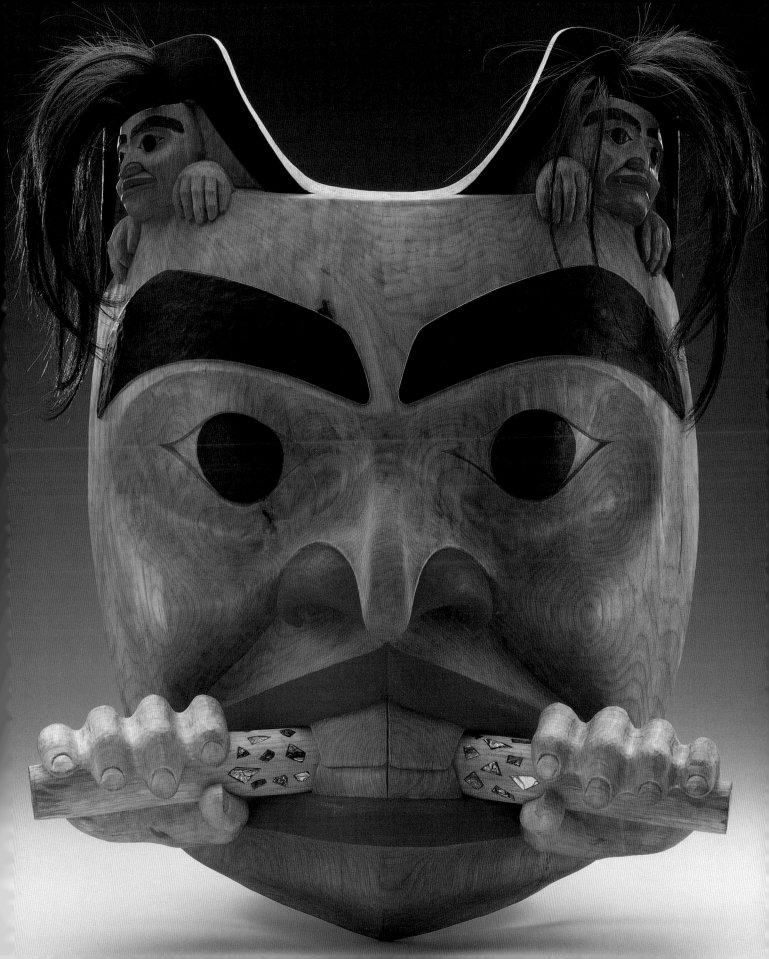

MEDICINE BEAVER

NORMAN TAIT

(NISGA'A)

ALDER, HORSEHAIR,
ABALONE SHELL, PAINT
22" X 17.5" X 7.5" (1989)

The Medicine Beaver is part of a legend that originated on the Nass River, about a giant Beaver that lived just across the river from the village where my great-great-great-grandfather was born. This Beaver had great powers, symbolized by a burning stick held in its mouth, and was a menace to the people of the village. It would lie in wait to kill hunters and fishermen who were caught off guard.

Now, on the shores of the river lived a great and powerful shaman. The people of the village asked him to help them. After some days of thought, he agreed to help. He went to the forest and gathered herbs for cleansing his body and his spirit. Then he sang his song to call on his spirit helper to come and give him power. The spirit came and entered his body. Then he was ready.

He loaded his canoe with devil clubs and his magic robe for protection, then paddled to where the Medicine Beaver lived and proceeded to taunt and ridicule him. The Medicine Beaver came to him, and they began to wrestle. They wrestled for days and days. The villagers could hear them fighting and feared for the shaman. After many more days, the Beaver was exhausted and all was quiet. Soon the shaman came paddling back with a beaver robe and claimed the Beaver as his spirit helper. This is how the Medicine Beaver mask came into being.

SUN MASK

JOE DAVID

(NUU-CHAH-NULTH, CLAYOQUOT)

RED CEDAR, CEDAR BARK, PAINT
28" X 37" X 8" (1990)

Two sources influenced this mask, one being the really old Sun masks with strong geometric forms, which have had a strong influence on my work, and the second being my involvement in the Lakota Sun Dance ceremonies, which I have participated in for the past six years. I have an interest in and seek out the spiritual expressions of other native cultures as well those of the Northwest Coast and bring these influences into my work. My reason for pursuing this interest is personal, and it is a life-long commitment that I have made to myself.

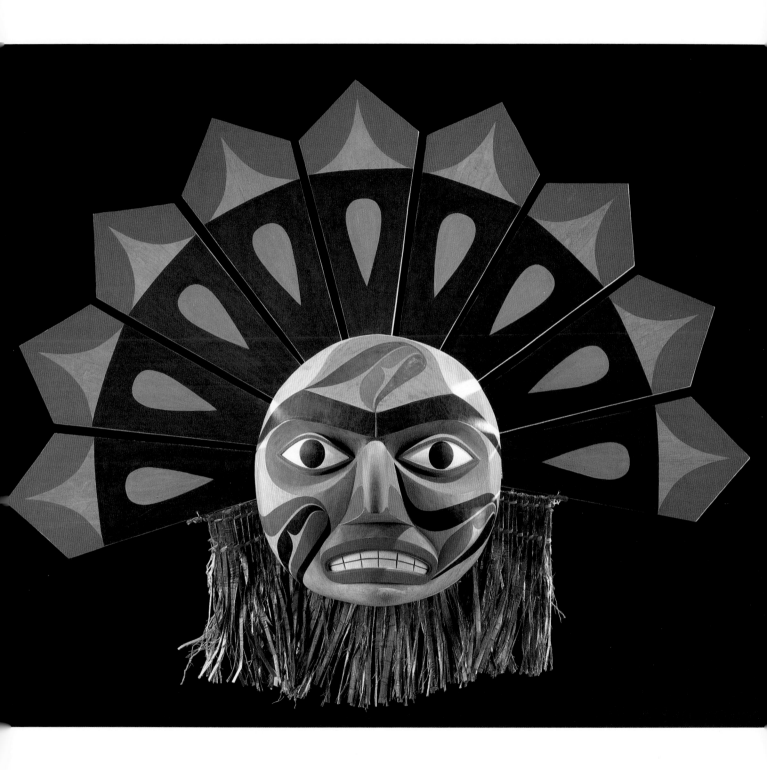

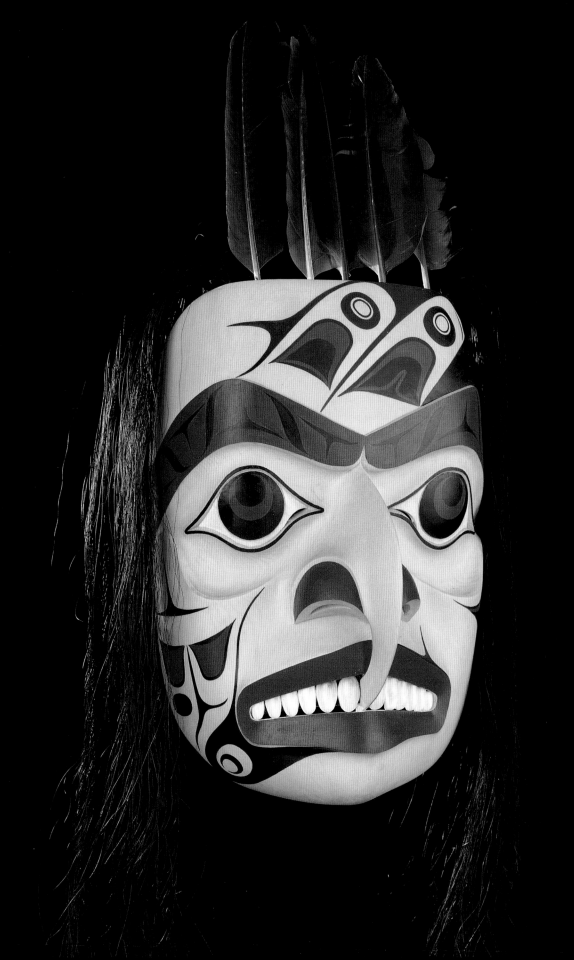

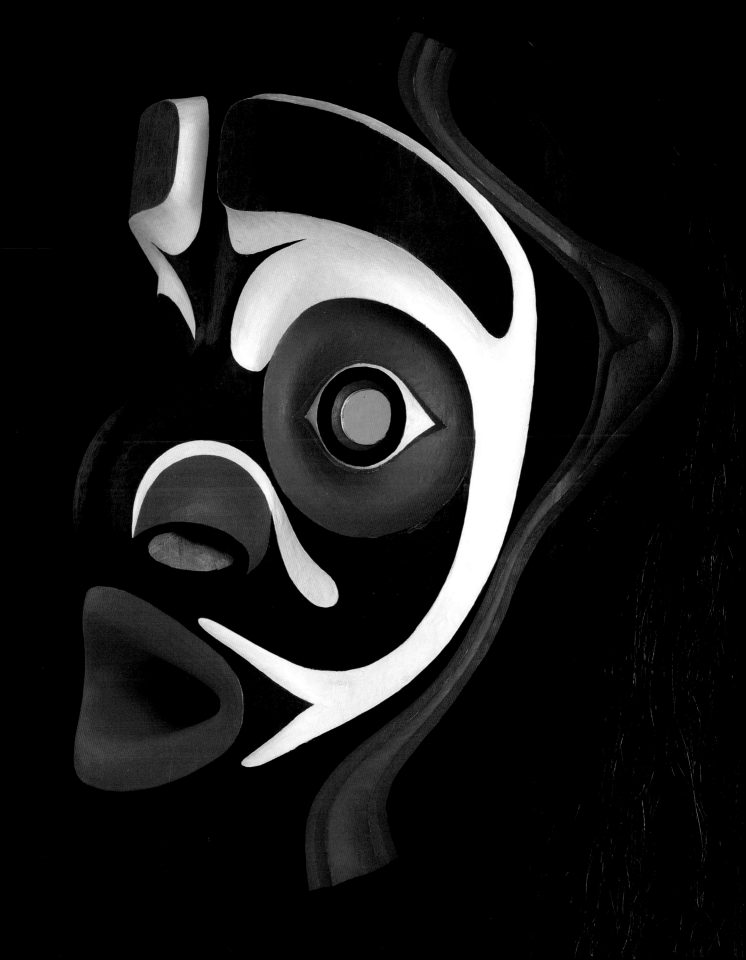

THUNDERBIRD SPIRIT

DON YEOMANS

(HAIDA)

ALDER, FEATHERS, PAINT, OPERCULUM SHELL, HAIR
20" X 8" X 7" (1993)

The Thunderbird is a common mythological being known to all the tribal groups of the Northwest Coast. Physically, Thunderbirds are supposed to be of gigantic proportions. The clapping of their wings is the sound of thunder, while the glint in their massive eyes translates as flashes of lightning. So large and powerful are the Thunderbirds that it is said they routinely plunge into the ocean to seize whales, much like an eagle would prey on a small fish.

I chose to call this mask Thunderbird Spirit because, to me, Thunderbird is a spirit, or rather a force of nature, as opposed to a large bird of prey. With characteristic piercing eyes and crisp brow line, the birdlike suggestion is complemented by feather decorations painted on the face and a crown of real feathers. Like all spirit masks, the nose has a distinct hook, a beaklike shape with human nostrils. I felt that by keeping the face in human form and adding long hair and operculum shell teeth, the mask might ultimately allude to the true creators of this majestic being. Thunderbirds, you see, do exist in the hearts and imaginations of those who are still in awe of nature.

DZUNUK̓WIS

BEAU DICK

(KWAKWA̲KA̲'WAKW)

RED CEDAR, HORSEHAIR, MIRRORS, PAINT
17" X 5" X 8" (1987)

The world of Ḵumugwe', chief of the undersea kingdom, is very much like this world, with both a natural and a supernatural side. The structure is also very much the same, with many of the beings having a similar counterpart in the undersea kingdom. The *dzunuk̓wis* is the undersea equivalent of the *dzunuḵwa*, the giantess who lives in the forest. She is always very sleepy, and when she dances she sometimes falls down, and her attendants must wake her.

This mask is based on an older mask, documented as a *baḵwas* (wild man) mask, that was returned to the U'Mista Cultural Centre in Alert Bay as a part of the return of cultural property from the Canadian Museum of Civilization in Hull, Quebec. There were numerous discussions between artists and elders concerning some of the possible discrepancies in the documentation, and I, with many others, believed that the characteristics of this mask belonged to the *dzunuk̓wis*. This is all part of our history becoming our own through our beliefs and interpretations.

FROG MOTHER/CHILD SPIRIT

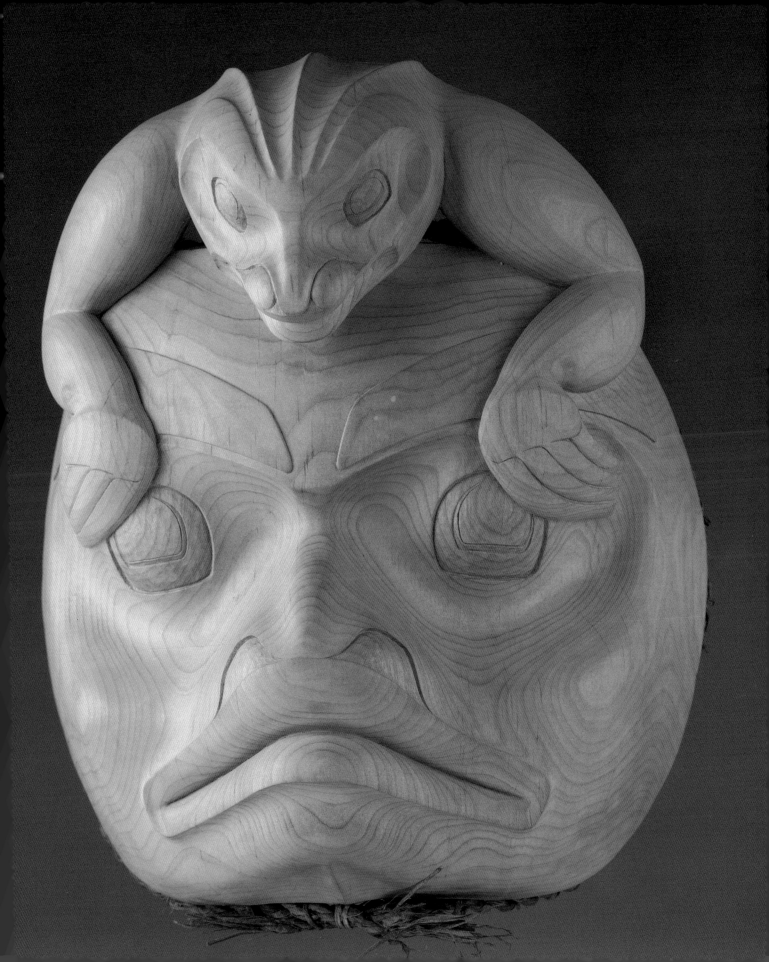

MUGAMTL MASK (CROOKED BEAK)

BEAU DICK

(KWAKWAKA'WAKW)

RED CEDAR, CEDAR BARK, PAINT

24" X 26" X 16" (1993)

FROG MOTHER/CHILD SPIRIT

NORMAN TAIT

(NISGA'A)

ALDER

15" X 12" X 9" (1992)

There were three boys playing near the river, building a fire to keep warm and cook the trout that they had caught. A small frog wanted to get into the river but had to pass by them. Twice, the boys tossed the frog back into the woods. The third time, they tossed the frog into the fire, where it burned to death.

That evening, the woman who watches over the forest realized one of her children was missing. She came to the smouldering fire and saw the burned carcass of her forest child. She wandered, crying, until she came to the camp of a blind man. She told him that the boys had killed the frog out of cruelty and must be punished.

The blind man went to the families of the boys, but they did not think their boys needed to be punished for the death of one frog. Again, the old man went to the village, but this time they laughed at him. The woman told the old man to leave and travel far away from the village. She then went up the mountain and implored the earth to cover the village for its disregard of the lives of her children. The mountain erupted, killing them all. To this day you can see where the lava settled for miles around the Nass valley. This is a reminder that all lives are precious and should be taken only for food, clothing or when absolutely necessary.

This mask comes from Kingcome Inlet. Today there are many versions of it. Originally, Gitsilas was a high-ranking man who was being worked on by witch doctors hired by other chiefs to eliminate him. As a result, he became very ill. When he was near death, his brother took him from the village to a cave and left him some food and water. Then his brother returned to the village to report Gitsilas was dead. The doctors burned their objects of witchcraft directed at him.

Gitsilas was able to revive himself and received supernatural abilities, including the ability to fly. He could fly between mountains, and his cry was heard all over the valley. When he returned home, he brought this mask back with him as one of his gifts. He was the first to dance this mask. Several families that are descendants of Gitsilas have the right to use this special mask.

Dennis Johnson gave me technical assistance with this mask.

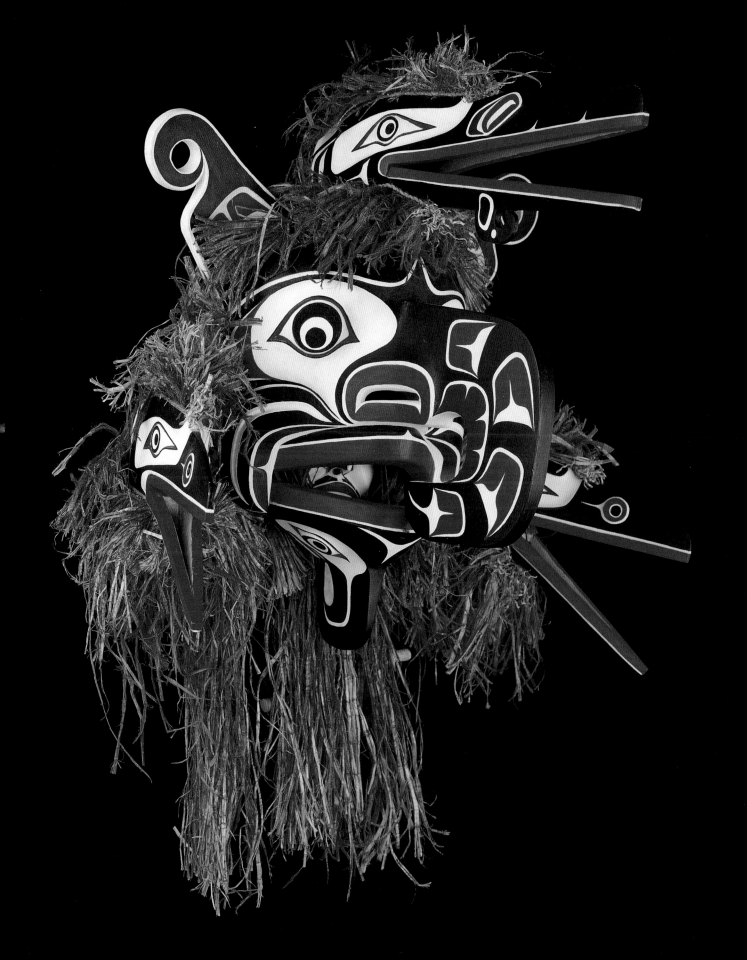

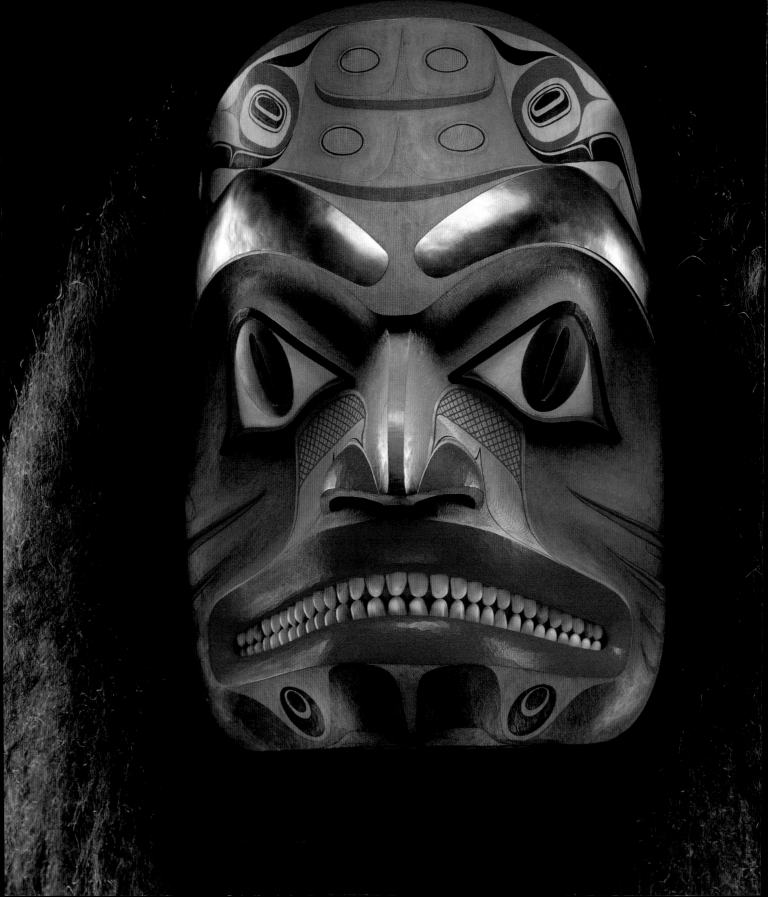

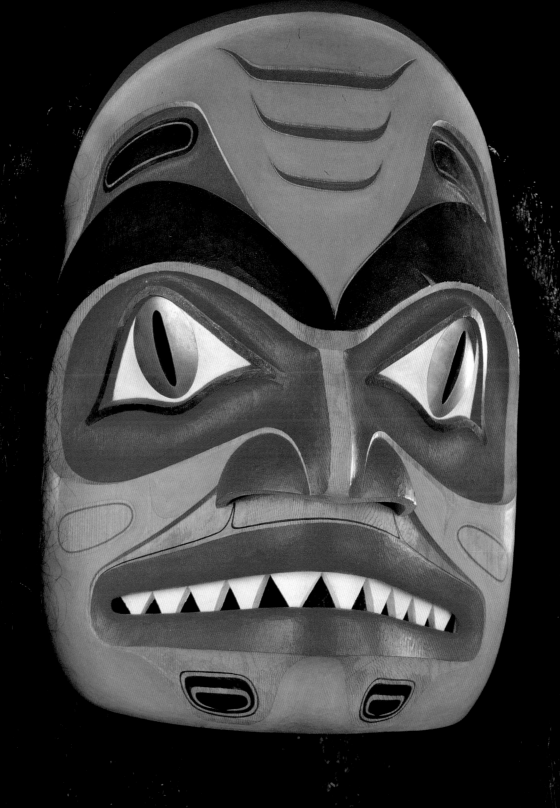

DOGFISH MOTHER

ROBERT DAVIDSON

(HAIDA)

RED CEDAR, HUMAN HAIR,
COPPER, OPERCULUM SHELL, PAINT

13" X 9.5" X 6" (1989)

SHARK

ROBERT DAVIDSON

(HAIDA)

RED CEDAR, HUMAN HAIR,
COPPER, GRAPHITE, ACRYLIC

13" X 9" X 7.5" (1989)

The title Dogfish Mother comes from the direct translation of the Haida word for "shark" to English. This mask grew out of my jewellery experience. Charles Edenshaw, a great Haida artist, was also a jeweller, and this influenced his pieces in other media. I am conscious of how the various media that I work in intertwine. For example, since I began designing Feastwear (the fashion collaboration with my wife, Dorothy Grant), I became aware of the motion and fluidity that is necessary in clothing design, in my graphic work and my art in general. With this mask, I was setting up challenges for myself based on other experiences, personal and artistic, that led up to it. The copper work on it suits the image.

The Shark mask was a carving challenge. Red cedar has qualities that are perfect for masks. It has a straight grain, is knot-free, and so on, though it is difficult to cut against the grain while maintaining the humanlike features and sharp edges. I took all of these variables into consideration in carving this mask.

EXECUTIONER

JOE DAVID

(NUU-CHAH-NULTH, CLAYOQUOT)

RED CEDAR, HORSEHAIR, GOAT HAIR,
CEDAR BARK, FEATHERS, PAINT

39" X 13" X 9" (1993)

This mask portrays someone who is very senior, but who still possesses his physical strength and mental faculties. Although Executioner is a strong and appropriate description, there are other aspects to this character that are equally important. He is also very knowledgeable about protocol and taboos associated with ceremonies and is, therefore, delegated some of the more sensitive tasks.

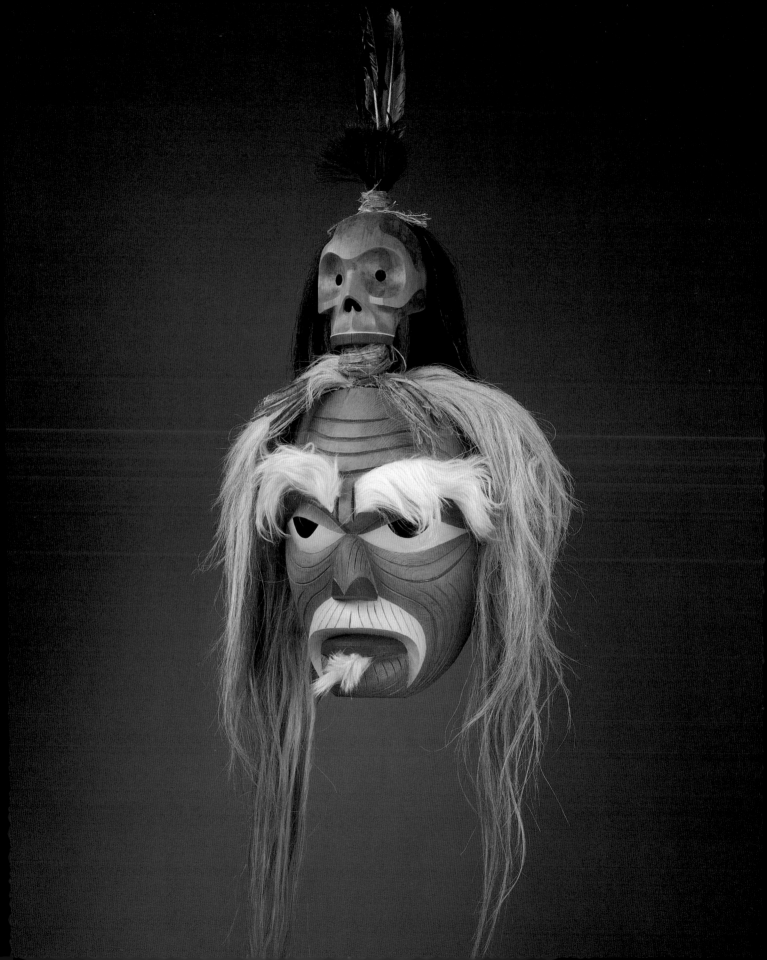

PUGMIS

BEAU DICK
(KWAKW<u>A</u>KA'WAKW)
ALDER, CLOTH, HORSEHAIR, PAINT
14" X 13" X 8" (1987)

There are many tribal and village variations to this mask, and many ways to describe this character. The *pugmis* is the parallel to the *b<u>a</u>kwas* (wild man), only in the undersea world, though the *pugmis* is a specific wild man with mannerisms and a relationship unique to each village and the circumstances of the time.

This is a great character to carve. I have done numerous interpretations of this character, altering the scale, texture and features of the mask. The power of this mask, with its stark white face, spiralling features and blowing mouth, is very dramatic and challenging to capture.

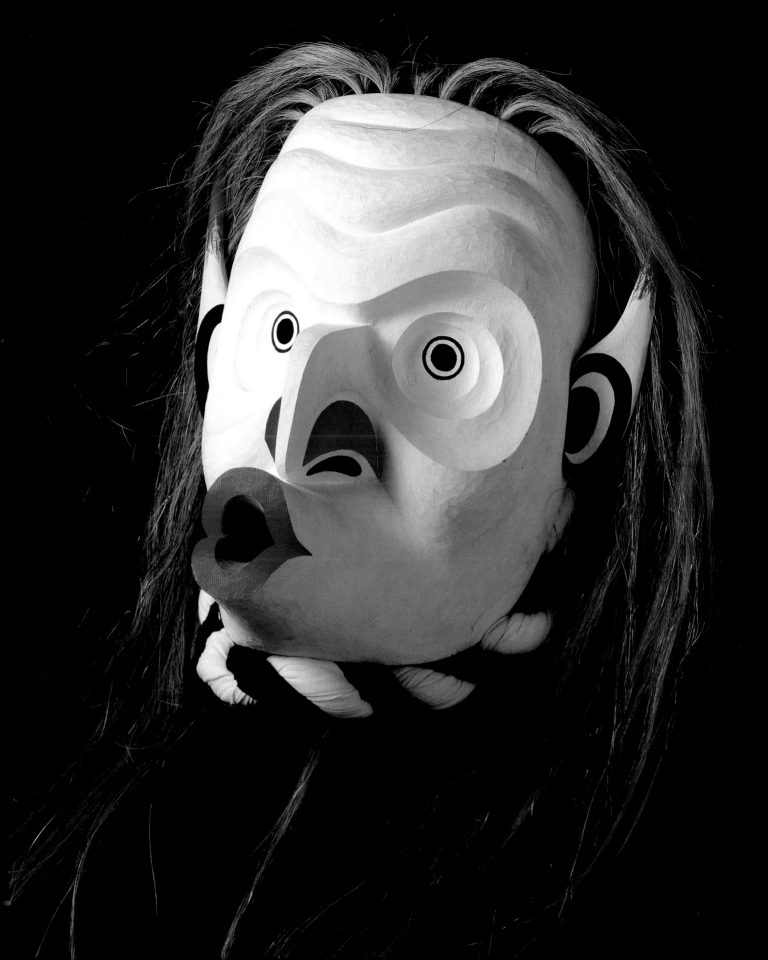

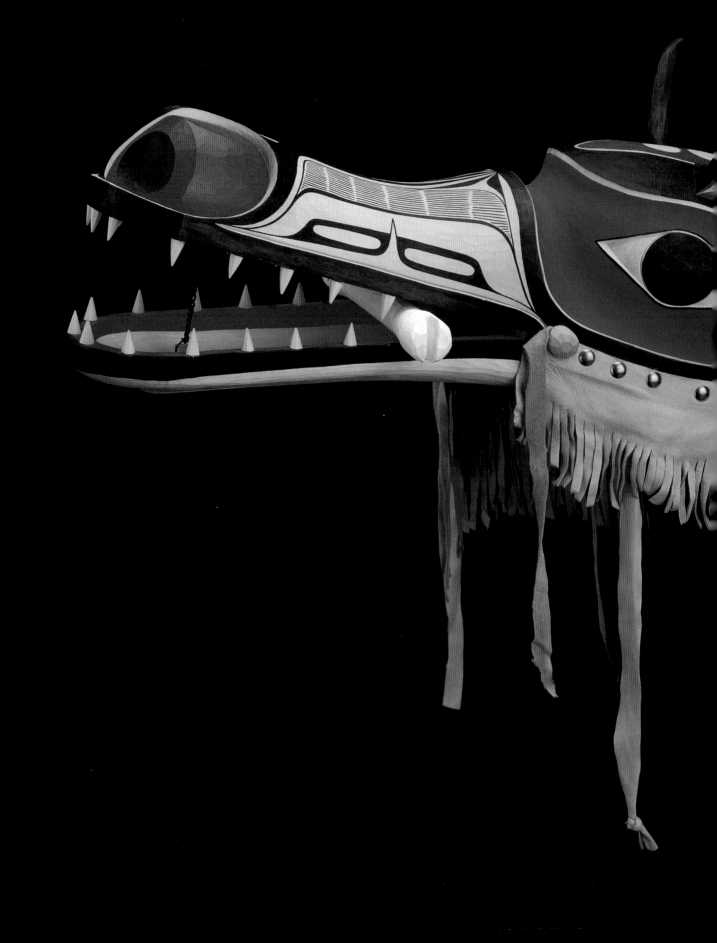

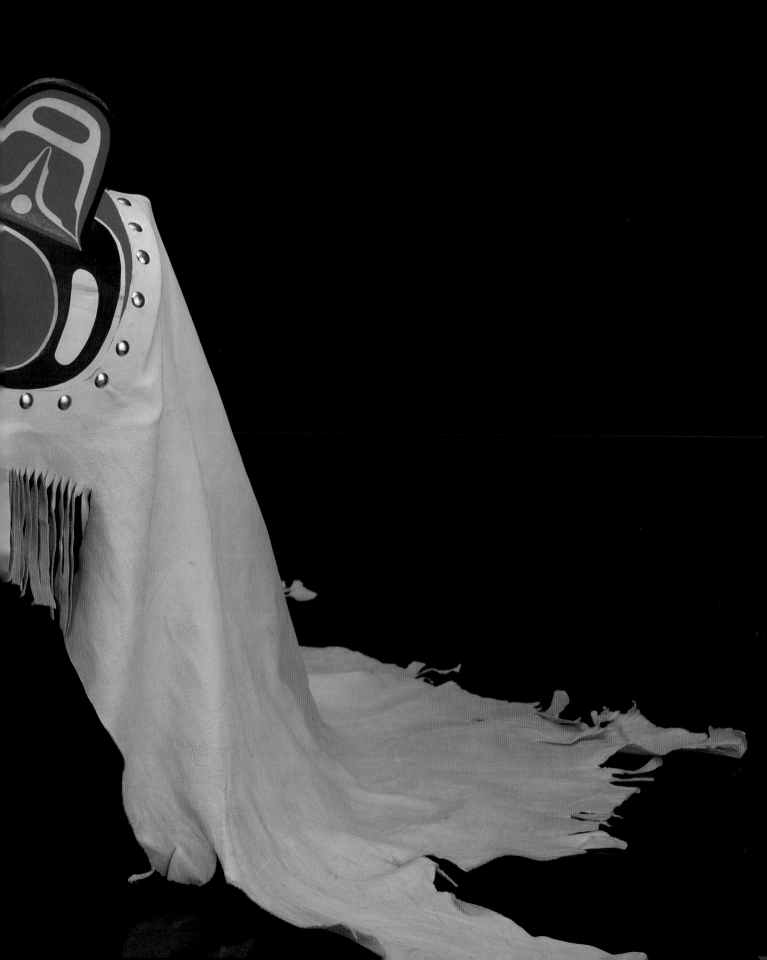

WOLF HEADDRESS

LYLE WILSON

(HAISLA)

YELLOW CEDAR, LEATHER, PAINT

9.5" X 21.5" X 8.5" (1992)

In very ancient times there existed a series of secret societies, one of which was the Wolf Dancers (or Dog Eaters) Society. There were specific privileges and duties for members of this society. Access to participation in this society was hereditary, although membership was earned through participation in many ceremonies over several years. All participants were carefully scrutinized and tested, with many failing. To the successful dancer, the rights were hard won, highly prized and zealously protected.

This society is no longer active among the people of Kitimaat, although a few elders still speak of the Wolf Dancers Society. The dancers were very ferocious, and before contact with Europeans, live dogs were killed to demonstrate the zeal of the performers. Later, these live dogs were replaced by replicas and carved props to simulate the killing.

The teeth on the headdress are carefully cut from white sapwood, and the bone represents what is left after the kill.

CROOKED BEAK

GLENN TALLIO

(NUXALK)

RED CEDAR, CEDAR BARK, PAINT

21" X 37" X 12" (1992)

The Crooked Beak is one of three cannibal birds that are part of the *hamatsa* ritual, which is an essential part of the *kusiut* (secret society ceremonies). The Crooked Beak is the third and final of the three birds to be danced, each responding to the whistle announcing his arrival to the initiates of the *hamatsa* society. A high level of skill is needed to perform with these large masks, and the dancers were known to spend several months physically and mentally preparing for this arduous task. The right to use this mask is handed down through families of successful initiates, and the stories pertaining to its origins and use still remain guarded within the oral traditions of the Nuxalk.

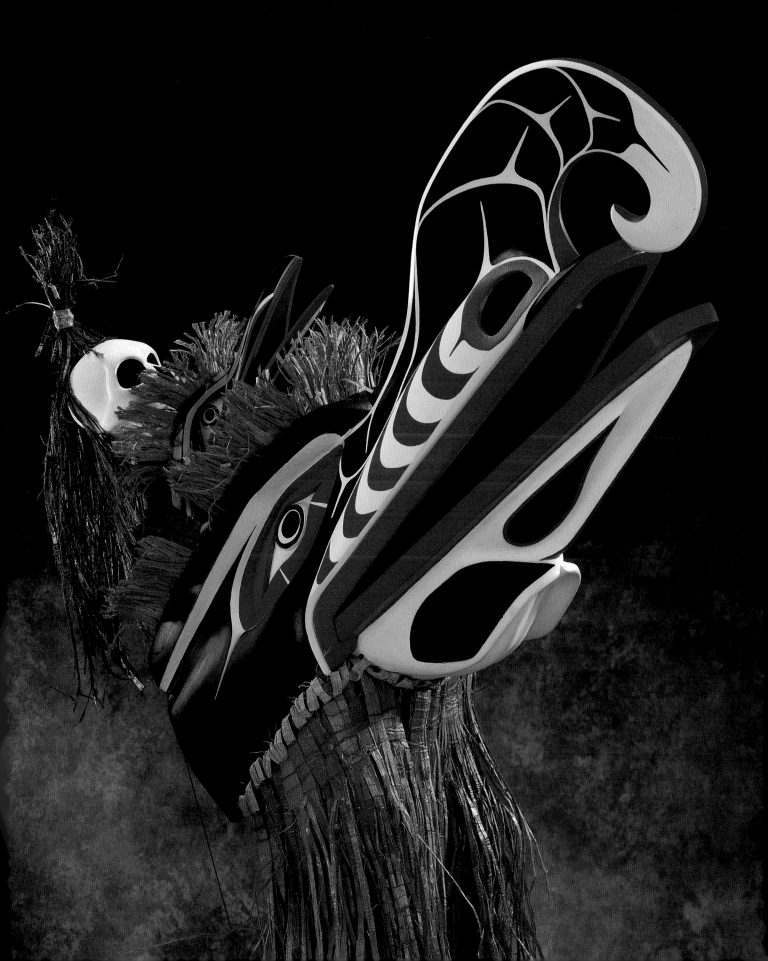

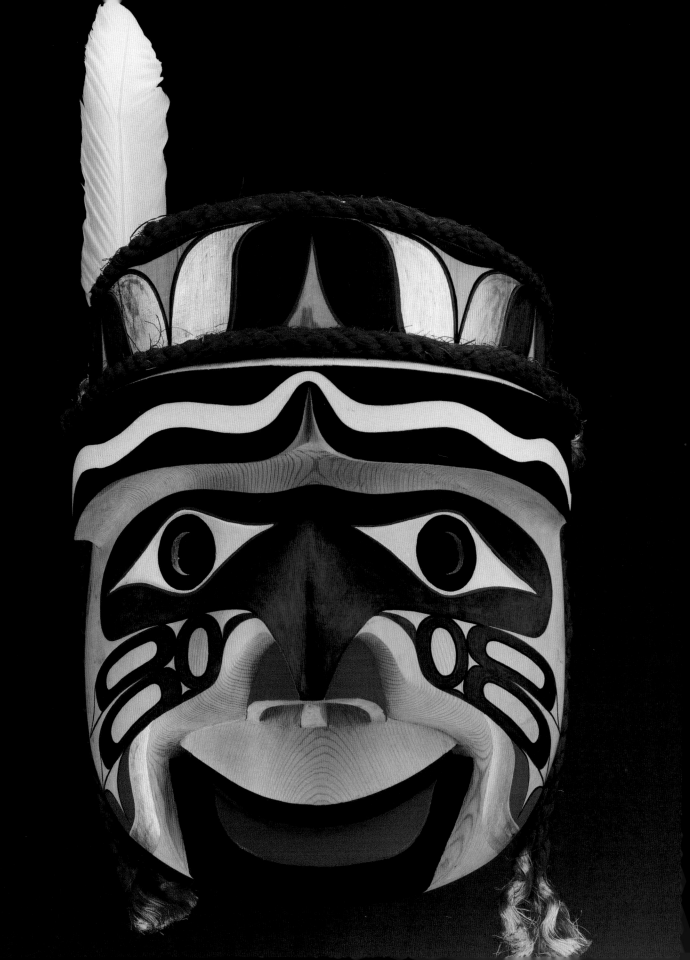

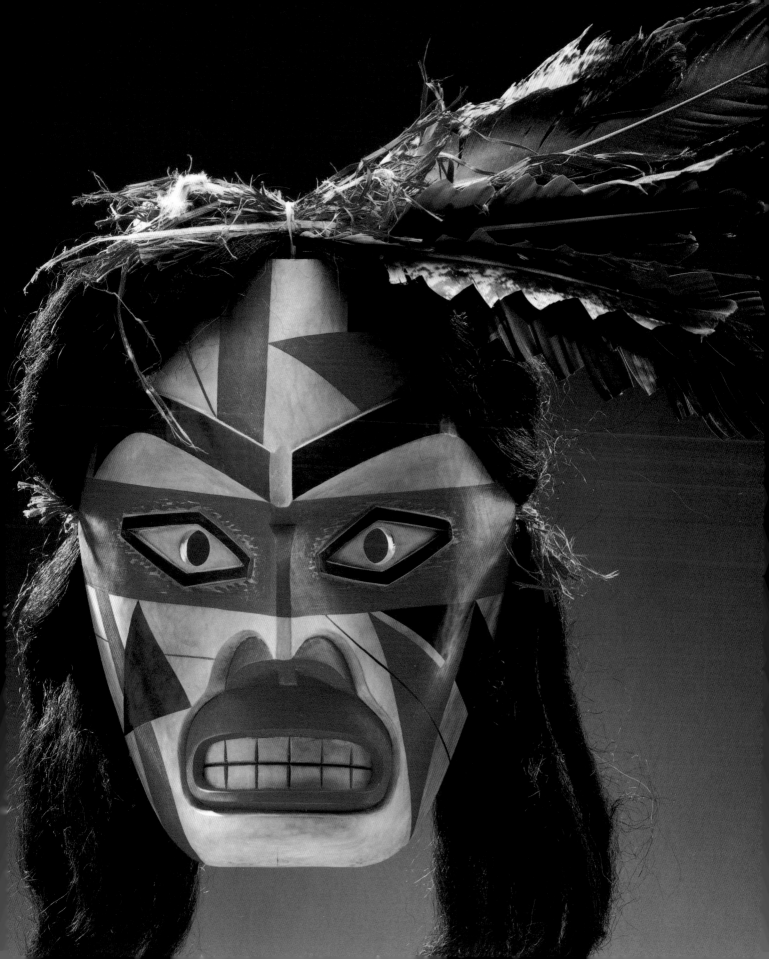

EARTHQUAKE

TIM PAUL

(NUU-CHAH-NULTH, HESQUIAT)

RED CEDAR, DYED CEDAR BARK, FEATHERS, PAINT

12.5" X 9" X 7" (1989)

The Earthquake mask is Tagit, an ancestor who lives on the mountainside. If nature is disturbed or abused in any way, Tagit will at times remind us of how small we really are and of the respect we all must have for nature. He can cause tremors or really major earthquakes.

WARRIOR

JOE DAVID

(NUU-CHAH-NULTH, CLAYOQUOT)

ALDER, HORSEHAIR, FEATHERS, CEDAR BARK,

DYED ROPE, PAINT

16" X 9" X 6" (1989)

The geometric cuts and designs I have used are common on older masks. These forms were intentionally abstract to keep information personal to the dancer hidden. If someone from a family of limited social recognition rose to a position of honour through valour, then his personal spiritual preparation, such as herbs, amulets, etc. would probably remain secret. However, he was obliged to ceremonially present his story or journey to the tribe. By keeping this information private, he retained the knowledge within his own family, which could raise their social standing in the future.

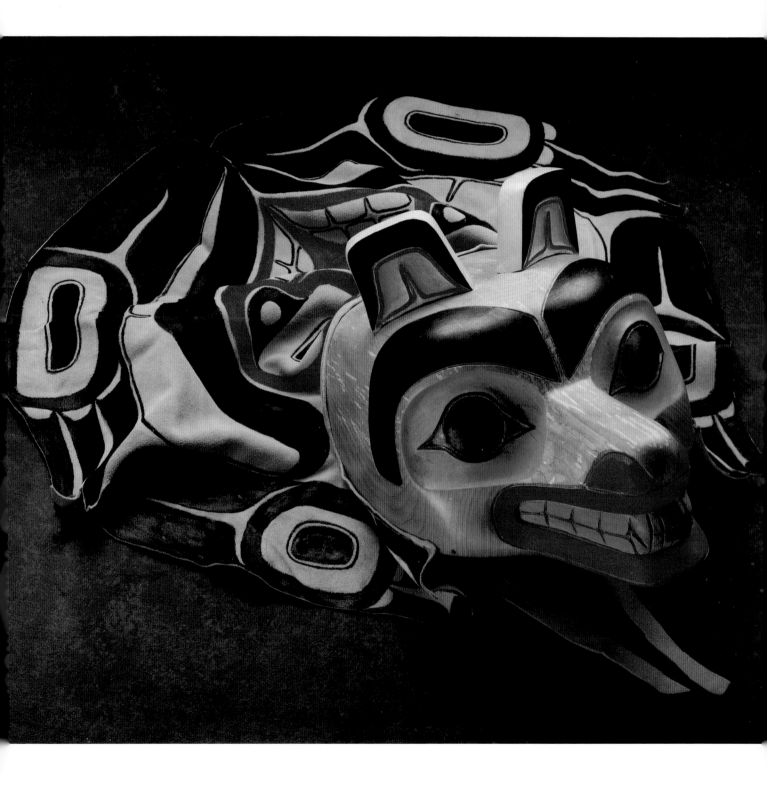

ROPE MAKER PRINCE

ROBERT JACKSON

(GITKSAN)

SILVER BIRCH, CEDAR BARK, COPPER, PAINT

10" X 8" X 4" (1988)

BEAR HEADDRESS

FREDA DIESING

(HAIDA)

ALDER, LEATHER, PAINT

8" X 22.5" X 23.5" (INCLUDING CAPE) (1989)

There are many stories about bears, although this piece was not carved in reference to a particular story or crest. I was attracted to the merging of flat design in the leather cape and the three-dimensional carving of the mask. This piece is a good example of my own personal style, which is semirealistic. Having been both a student and a teacher of Northwest Coast art, I have seen how the influence of other artists and styles creeps into an artist's work; therefore, I don't describe by own style as Haida or Tsimshian. There are also elements that are definitely my own.

When the Gitanmaax School first opened in Hazelton, I studied Northwest Coast art with artists of different cultural backgrounds, and I have watched their styles evolve. I can read some of their influences based on their teachers, friendships and places of residence. I held numerous positions over the years at the school, mostly relating to costumes, the dance groups and co-ordinating the relationships between the elders and children.

Many of the pieces I carved then were narrative pieces intended to tell myths and stories. This headdress has a similar purpose, rather than being about one particular story or family.

The legend of the Rope Maker Prince tells of how this *naxnok* (supernatural being) brought cedar rope to the Gitksan people. This story is exclusive to my family, and its actual details are guarded by oral tradition.

Among the Gitksan, the right to use the mask is owned by one family, or house. Gitksan clans are divided into houses, and each house has its own masks along with their accompanying oral history. There are different kinds of masks, portraying characters that include human, animal and spirit beings. Every mask has a name that stems from its history, personality, character and function, and the name is handed down to succeeding generations together with the right to the mask.

The power of a mask does not lie in its beauty but in its name and the history behind it. Artistically, however, the beauty of the carving and the painted design do enhance the power of the mask.

The traditional way of the Gitksan is to commission masks, totem poles, rattles, headdresses and so on from an artist who belongs to a different clan. The final payment to the artist takes place in the feast house, where the payment and credit for the work are acknowledged by everyone present.

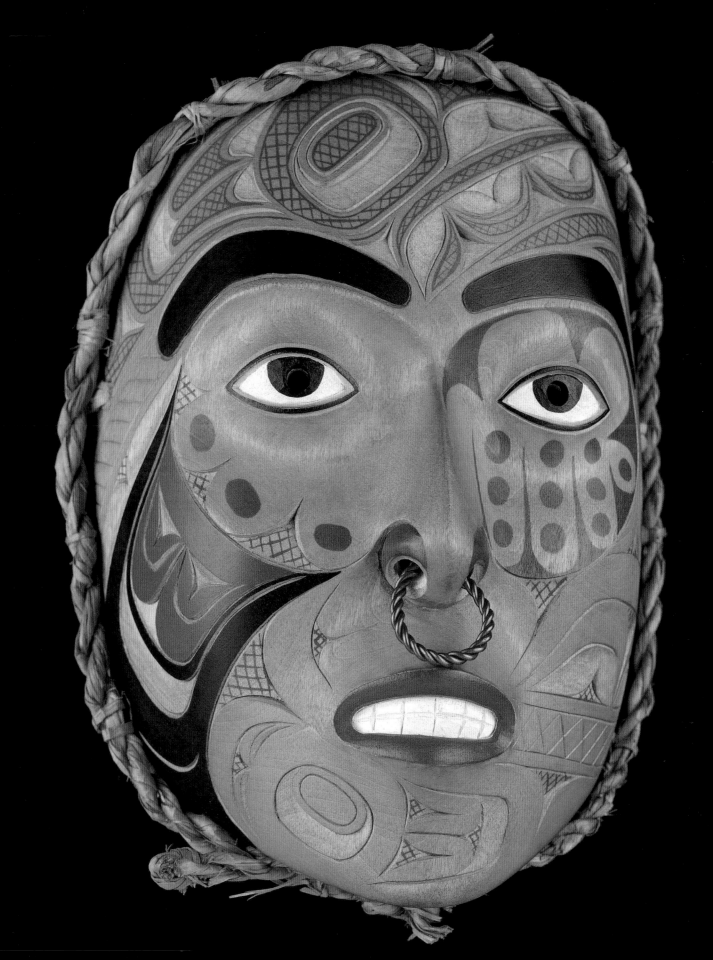

CLAN AND CREST MASKS

CREST MASKS MAY BE OWNED BY INDIVIDUALS, FAMILIES OR CLANS. THEY ARE

ASSOCIATED WITH STORIES THAT TELL HOW THE RIGHTS TO CRESTS, NAMES, SONGS

AND OTHER PRIVILEGES WERE OBTAINED. THE DISPLAY OF CLAN AND CREST MASKS

AT CEREMONIES CONFIRMS OWNERSHIP OF THEM, DEFINES THE TERRITORY IN WHICH

THE CRESTS ARE VALID AND BRINGS THE POWER ASSOCIATED WITH THE CRESTS TO

LIFE. INCLUDED HERE ARE FRONTLETS, WHICH ARE SMALLER PIECES WORN ON THE

FOREHEAD BY CHIEFS TO DISPLAY THEIR CRESTS ON CEREMONIAL OCCASIONS.

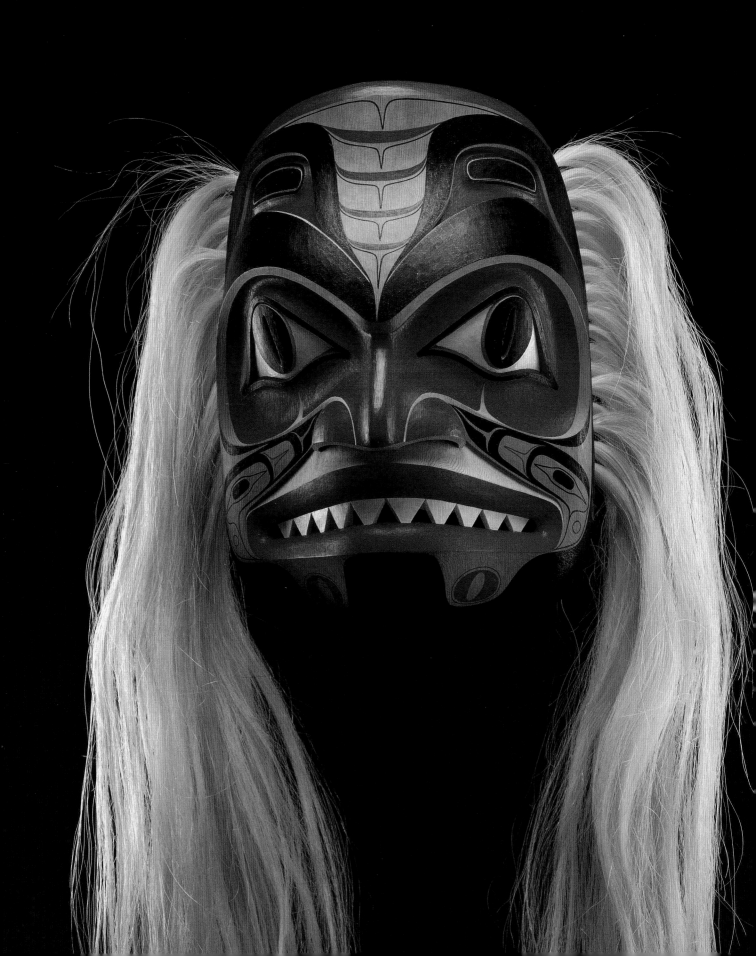

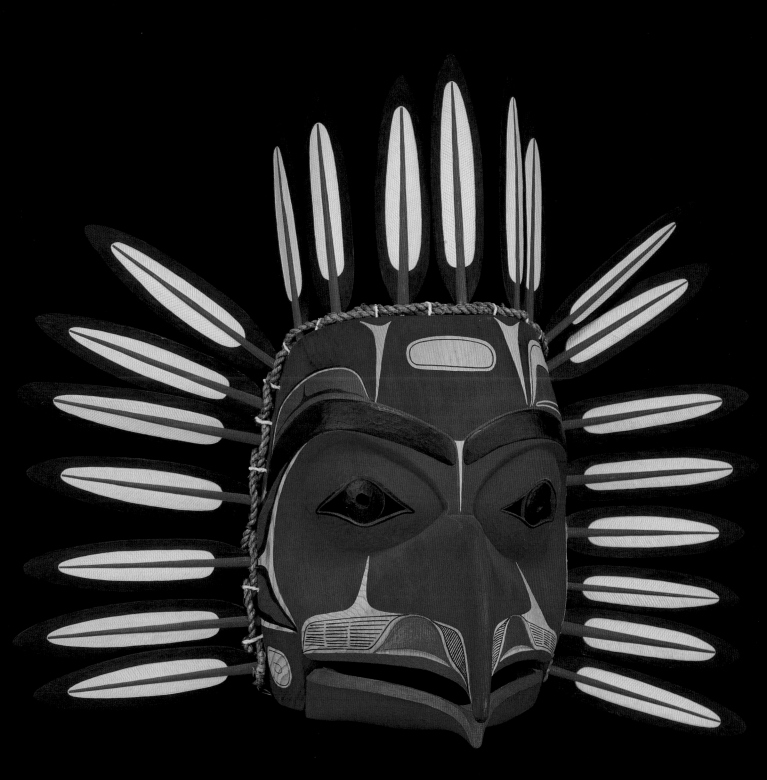

DOGFISH

ROBERT DAVIDSON

(HAIDA)

RED CEDAR, HORSEHAIR, GRAPHITE, PAINT
13" X 9.5" X 7" (1988-89)

Since this mask is intended to represent a young Dogfish, I used thick lips, a pudgy nose and thick lines to give it a round puppy-like feeling. Thin lips and thin lines would have created the appearance of an older Dogfish. I often set up artistic experiments to try to control a feeling that I have about a particular character or image. Often the source of this feeling is not clear to me at the time but is revealed later, sometimes much later.

My father belonged to the Shark lineage (the Haida language does not differentiate between Dogfish and Shark) of the Raven clan. The story of the Shark explains the origin of the crest. A young man rises very early and goes down to the shore to take care of nature. He hears a sound from farther down the beach and follows the sound to a Shark caught in a tide pool at low tide. The man releases the Shark, and the grateful Shark teaches the man a chant which becomes his personal song. This chant is still known and used today. I first heard it at the "Tribute to the Living Haida" potlatch in Massett in 1980, performed by a group from Hydaburg, Alaska. I was touched to hear this old song and traded one of our songs for it so that we would have this song as well.

EAGLE MASK

LYLE WILSON

(HAISLA)

RED CEDAR, YELLOW CEDAR, CEDAR BARK, PAINT
20" X 25" X 8" (1989)

The Eagle is an ancestral bird of my clan. The Eagle represents the universal characteristics of pride, beauty and ferociousness. The Eagle's flying prowess and its ability to soar high in the sky led to the belief that the Eagle could communicate with the spirits of the sky. The Eagle clan admired and adopted many of the traits of this great bird, going so far as hiring someone to pick up something that had been dropped because the true Eagle never dropped anything that it had grasped in its talons.

This mask was inspired by the sheer beauty of this great bird and my own observations of it, as well as by an older mask of a clan chief, Sunahead, which is the mask of the highest-ranking chief of the Eagle clan. I refused to use real eagle feathers because it would mean the death of an eagle. I chose to carve feathers out of yellow cedar, which contrasts with the mask of red cedar and still enables me to respect my ethical concerns.

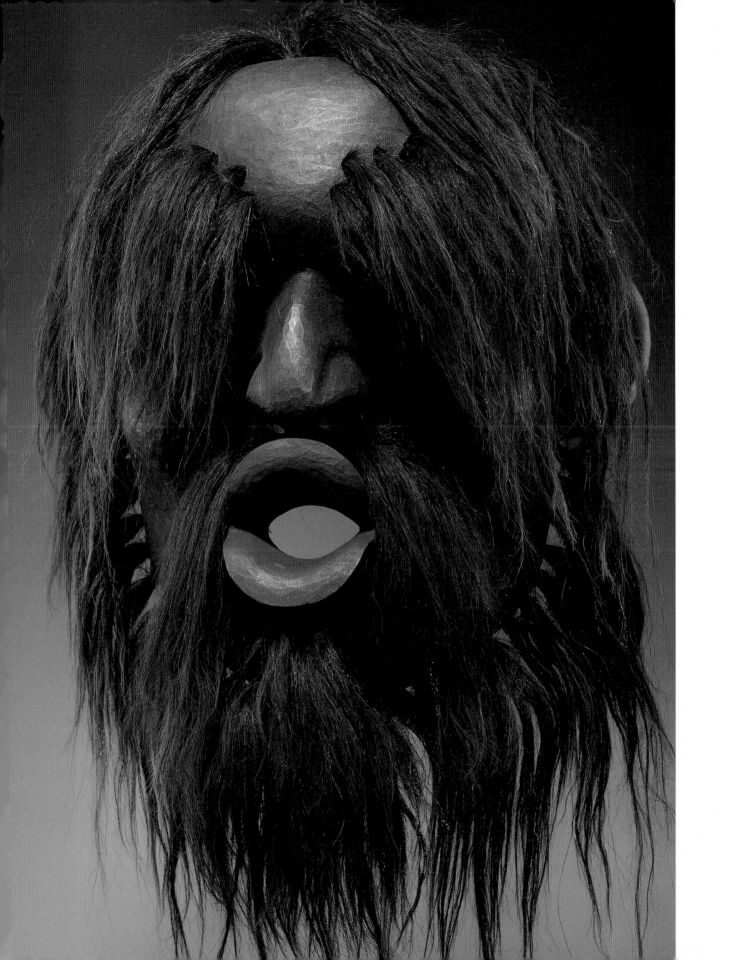

MEDEEKGEM GYAMK
(SUN BEAR)

EARL MULDOE
(GITKSAN)
SILVER BIRCH, PAINT
12" X 12" X 8" (1988-89)

DZUNUḴWA

BEAU DICK
(KWAKWA̱KA̱'WAKW)
RED CEDAR, HORSEHAIR, PAINT
22" X 21" X 10.5" (1993)

A *dzunuḵwa* is an eight-foot-tall giantess who lives in the forest. She is covered with bear fur and is almost blind. She is big and powerful, but she is also clumsy and stupid. On her back she has a woven basket in which to carry off young children, although in most stories the children are able to deceive her and escape. Parents use this story to keep children from straying too far from the village.

Dzunuḵwa is also familiar with the knowledge and power of the forest. The mask of *dzunuḵwa* is performed as the child-eating monster or hand-held by the chief during an oration using the image as a reference to the captured knowledge of her world. *Dzunuḵwa* is the most important crest owned by a chief.

The origin of this crest is said to go back to the time Kispiox was first established. The ancestors of the chief Gitludahl were camping at Shegunya, the salmon river opposite present-day Kispiox, and fishing for salmon.

A maiden in seclusion saw Medeekgem Gyamk, a bear wearing a sun collar around its neck, come down the river. Her parents killed the bear and gave her the crest for posterity.

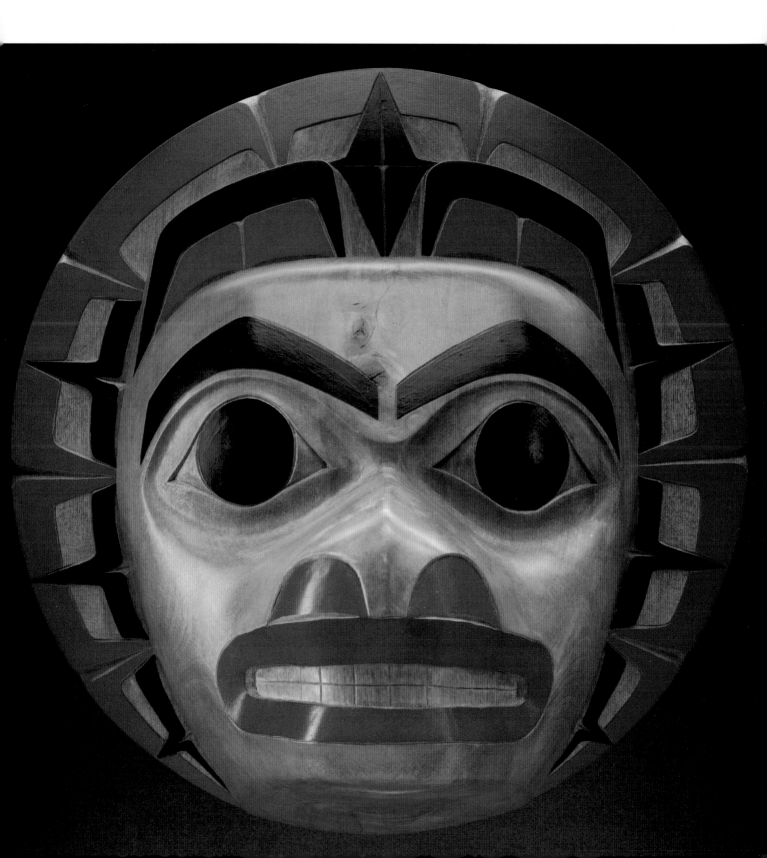

ANCESTOR MASK, RETURNED FROM THE WARS

ART THOMPSON
(NUU-CHAH-NULTH, DITIDAHT)
RED CEDAR, CEDAR BARK, HORSEHAIR, FEATHERS,
LEATHER, PAINT, BALLBEARINGS, CORD
24" X 13" X 9" (1989)

ANCESTOR MASK, THUNDERBIRD

ART THOMPSON
(NUU-CHAH-NULTH, DITIDAHT)
RED CEDAR, CEDAR BARK, HORSEHAIR, FEATHERS,
LEATHER, PAINT, BALLBEARINGS, CORD
24.5" X 15" X 10" (1989)

These two masks, along with their songs, came to me in a dream from my grandmother, with instructions to use them for our family and before all other dances.

One of them portrays a man who has been through a war and has come out the victor. He is bruised and bloody around the mouth. The other portrays another one of our important prerogatives, the Thunderbird.

The Returned from the Wars mask was used for the first time in 1989 at the Haida Spiritual Renewal Feast at the Aboriginal Friendship Centre in Vancouver. The Inuit Gallery graciously returned the Thunderbird mask to my family for the feast, so that the two masks could be reunited. At the feast, in a gesture of goodwill, we as a family shared the songs with Jim Hart, an artist of Haida descent.

ANCESTOR MASK,
RETURNED FROM THE WARS
(LEFT)

ANCESTOR MASK,
THUNDERBIRD
(RIGHT)

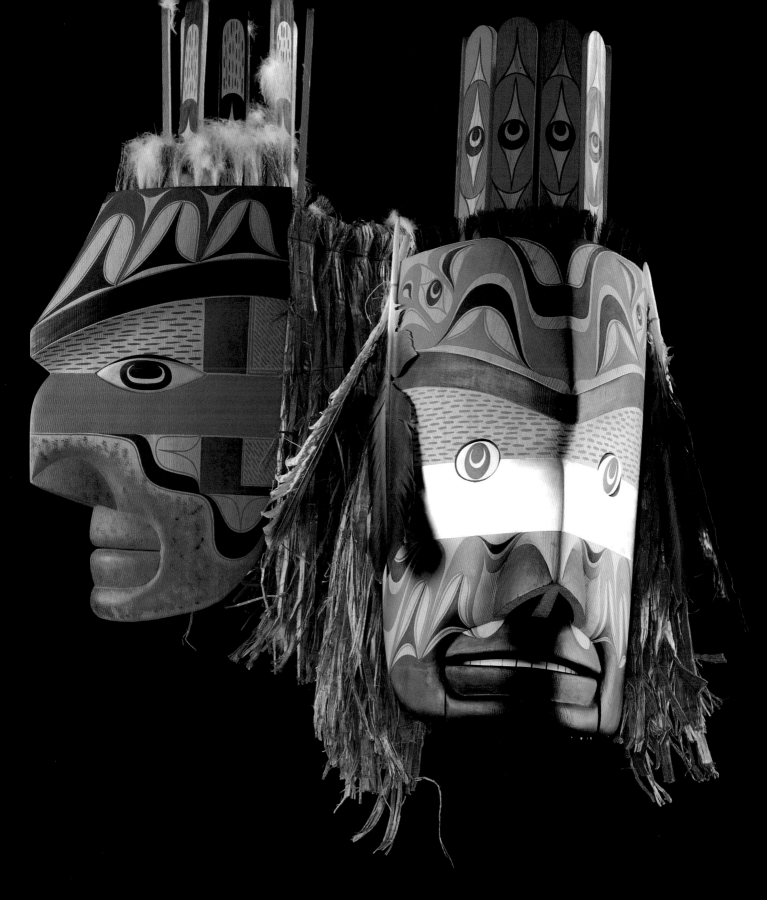

EAGLE FOREHEAD MASK

KEN MCNEIL

(TAHLTAN/TLINGIT/NISGA'A)

ALDER, ERMINE PELTS, LEATHER,

ABALONE SHELL, PAINT

5.5" X 8" X 9"

(EXCLUDING ERMINE TRAIN) (1989)

The Eagle forehead mask is reserved for the chief of the Eagle crest, who wears it at ceremonies to document ownership of a certain story to do with the crest. In each crest, different positions and details are carved into the mask to represent a certain story.

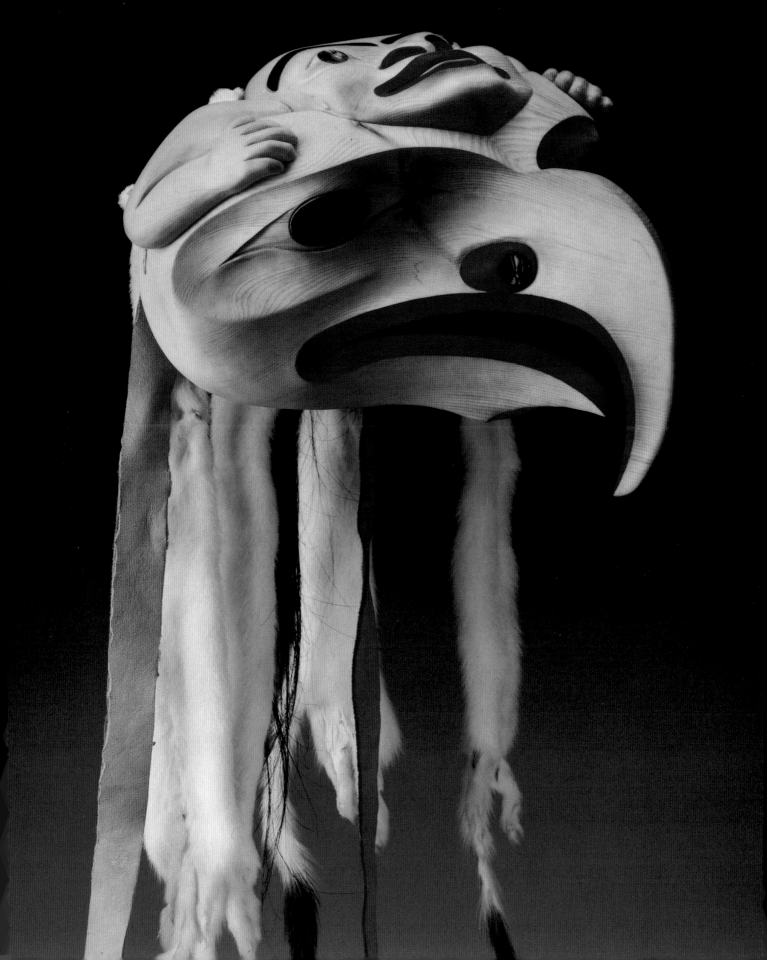

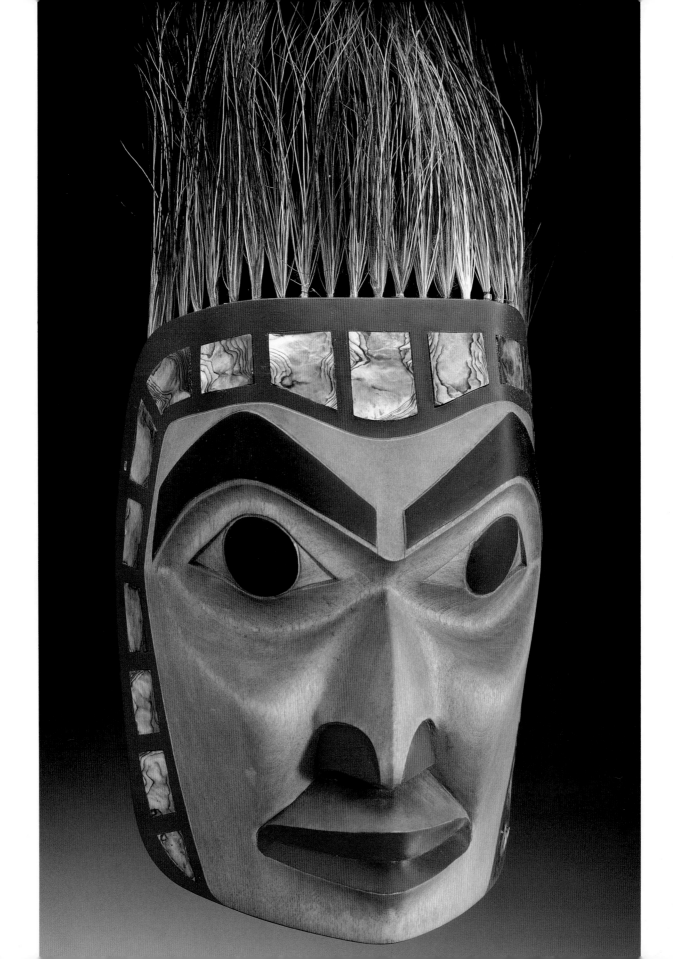

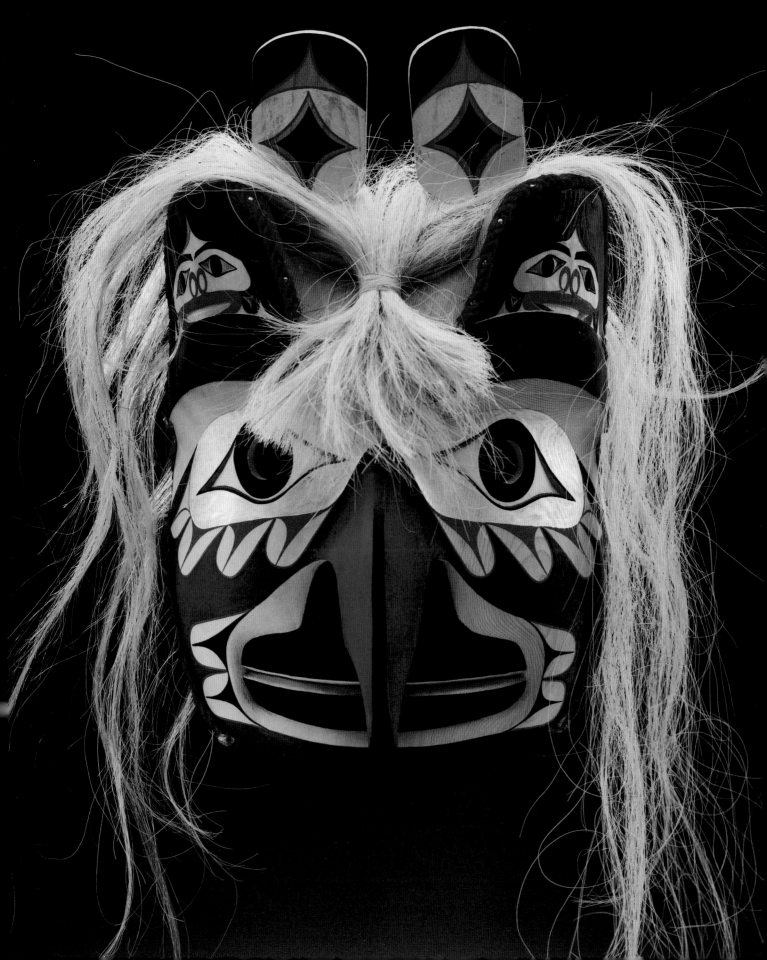

CHIEF WITH RAINBOW

EARL MULDOE

(GITKSAN)

SILVER BIRCH, ABALONE SHELL, HORSEHAIR, PAINT
11" X 7" X 5" (1990)

This mask originates from the village of Temlaham, which once stood just outside of Hazelton in northern British Columbia. Temlaham is said to be the Gitksan version of the Garden of Eden, where our people came from. Today, there is only a marker surrounded by farmland to acknowledge the location of this historic village.

The Rainbow people are part of the Fireweed clan. They are also known as the sky people because most of their crests are from the heavens. This mask is a modern version and in a style that is different from its totem pole counterpart which stands near Hazelton.

THUNDERBIRD

TIM PAUL

(NUU-CHAH-NULTH, HESQUIAT)

RED CEDAR, HORSEHAIR, ROPE, PAINT
17" X 13" X 9.5" (1989)

This Thunderbird comes from the northern region of the Nuu-chah-Nulth people, from Ca-win Mowachaht territory. Thunderbird lives high in the mountains. One day, Thunderbird came down from the mountains in his human form and took back with him a young woman from Mowachaht. She returned a year later with a baby boy. This is how our northern chiefs attained the right to bring out the Thunderbird in headdress form.

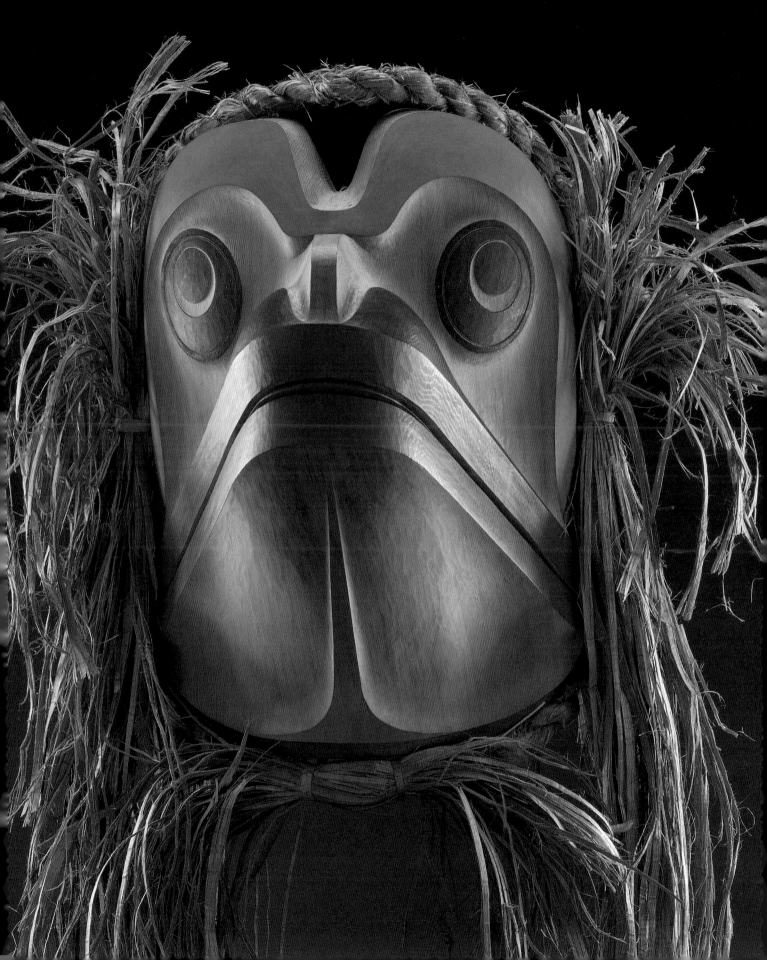

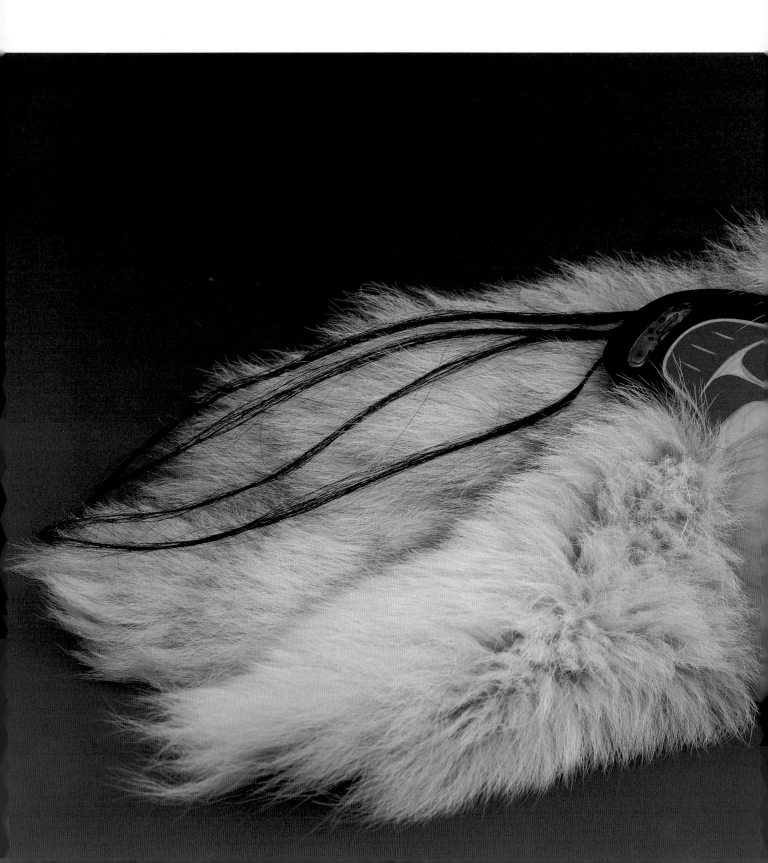

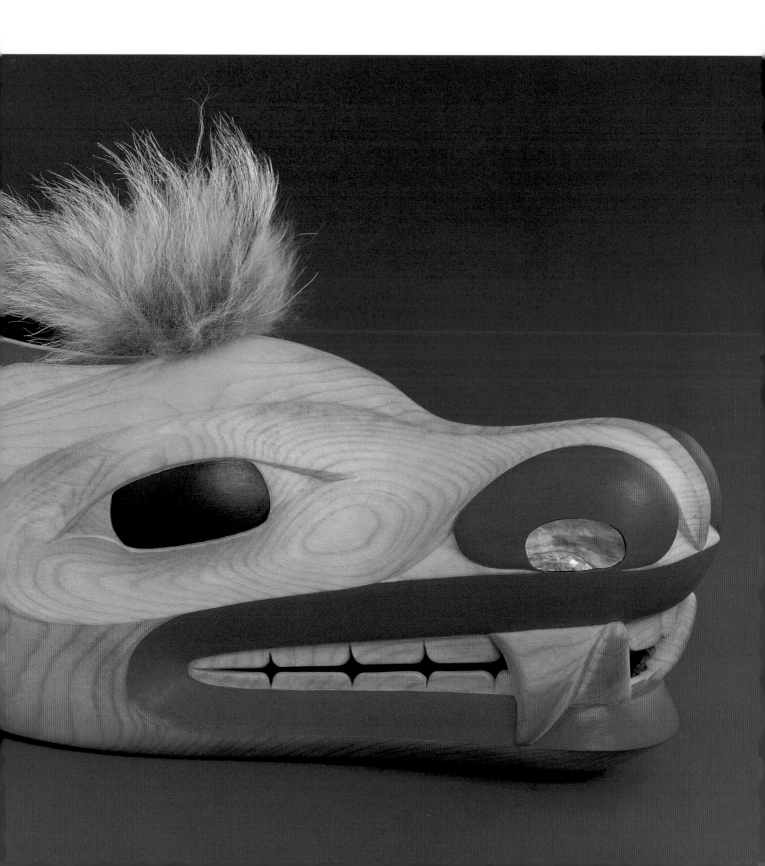

CRAB OF THE WOODS

ROBERT DAVIDSON

(HAIDA)

RED CEDAR, CEDAR BARK, PAINT

17" X 12" X 10" (1988-89)

Crab of the Woods is the actual English translation of the Haida word for frog. The Frog has become the symbol for my spirit helper. This is not something that I knew or understood right away. The first time I used a Frog mask was at a potlatch in 1981. The Frog was one the crests of Charles Edenshaw, the great Haida artist, and I carved it on the housefront of the Charles Edenshaw Memorial Longhouse, basing the design on an old Edenshaw piece. Later the house was destroyed by fire, and the dancing of the Frog mask ended a period of mourning for it. I needed to bring the Frog out one more time to put to rest the emotions associated with this event.

At the same time, I realized the meaning of portrait masks and masks in general. The word for mask in Haida means "to imitate." Masks make visual specific feelings. The Frog mask revealed this knowledge to me, and since then I have used the Frog as a personal reference point in my designs.

WOLF HEADDRESS

STAN BEVAN

(TAHLTAN/TLINGIT/TSIMSHIAN)

ALDER, WOLF FUR, HUMAN HAIR,

ABALONE SHELL, PAINT

6" X 6" X 12" (1988)

This Wolf crest originated on the Taku River, which is in the vicinity of the communities of Atlin and Telegraph Creek in northern British Columbia. The crest came from my great-great-grandmother and was handed down through matrilineal descent to my mother. The Wolf headdress is worn by a headman of the clan at ceremonies.

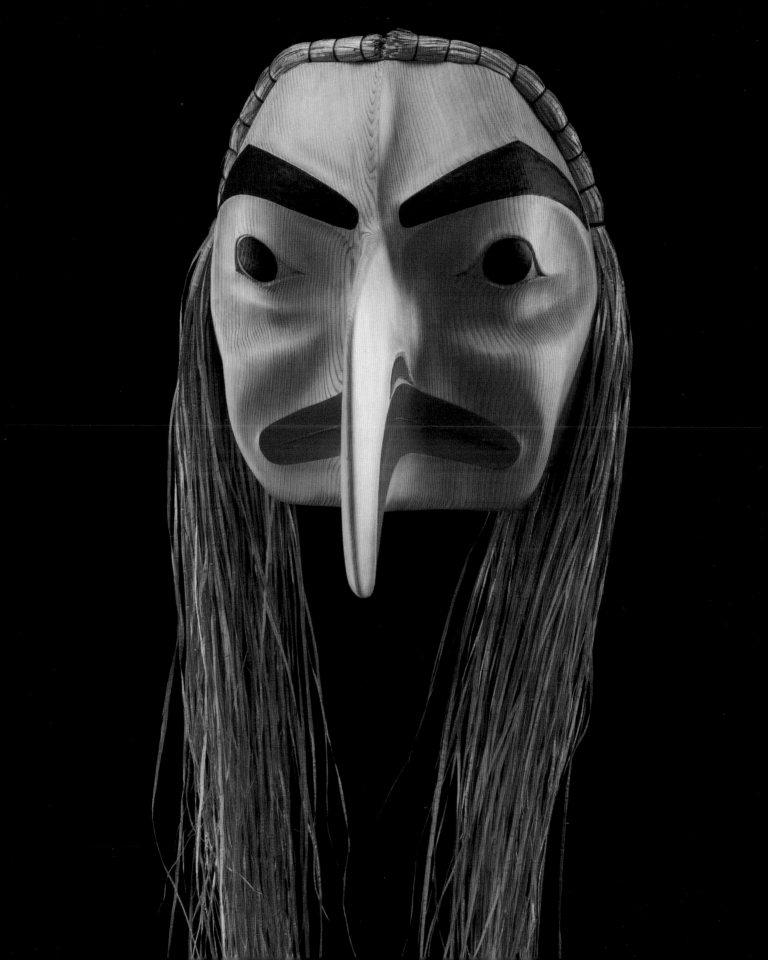

MOON MASK

TONY HUNT JR.

(KWAKW<u>A</u>KA'WAKW)

YELLOW CEDAR, PAINT

13.5" X 12.5" X 4" (1993)

EAGLE TRANSFORMING INTO HUMAN

TERRY STARR

(TSIMSHIAN)

RED CEDAR, CEDAR BARK, PAINT

15" X 11" X 15"

(EXCLUDING CEDAR BARK HAIR) (1989)

This is a crest mask representing the Eagle clan. I am a member of the Lax Skeek, or Eagle clan. The Eagle clan is one of four principal clan groups of the Tsimshian nation. The Tsimshian have an extremely complex social organization; for example, there are well over two dozen subcrests pertaining and belonging to the Eagle clan.

The Eagle Transforming into Human mask is an image I have done numerous times because of the limitless expressions that can be captured. For this reason it has become one of my favourite characters to carve, and one for which I will never be able to make all the possible versions. The protrusion on the forehead of this version represents the supernatural ability to transform.

The wood for this mask came from a red cedar tree that measured seven feet in diameter at the base. The grain of the wood was beautiful, and I wanted it to be a feature of the final mask. Therefore, I let the grain flow through the image, and I limited the paint, finally framing the image in straight golden cedar bark.

The Moon is one of my favourite masks to carve. Beyond the central moon face is the rim, which opens up to endless potential for two-dimensional design. There are many historical variations to this mask, including its use as a clan crest mask.

The story of the Moon that is most often told in ceremonies is the one about the Half Moon and the Full Moon arguing in a competitive sort of way to determine who should be out overseeing the ceremony in progress. They are a form of fool mask and mimic each other's actions and words.

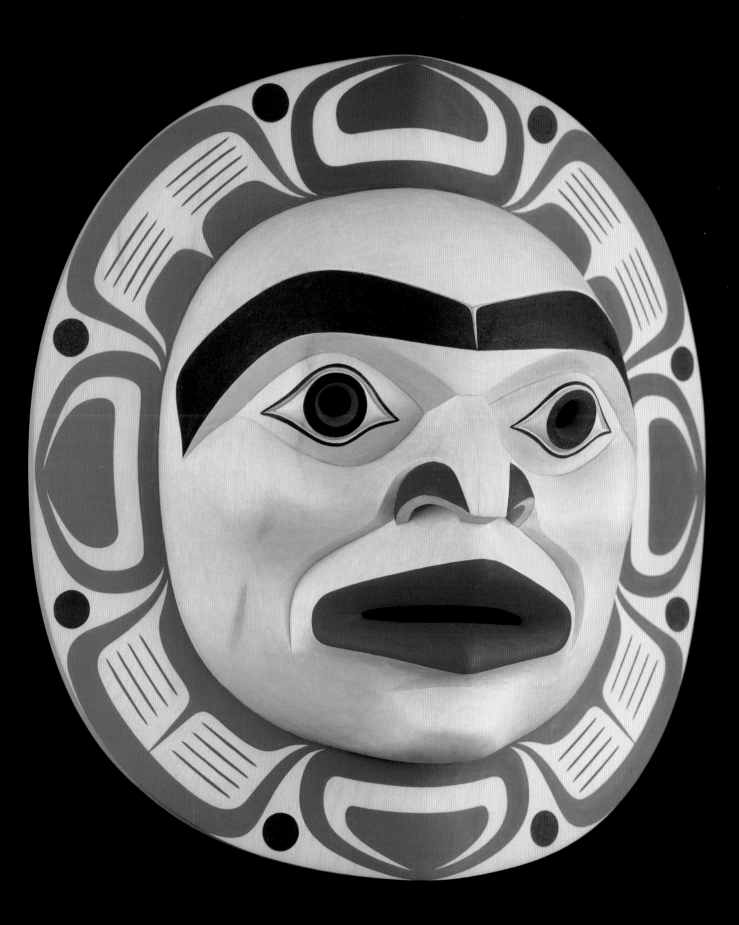

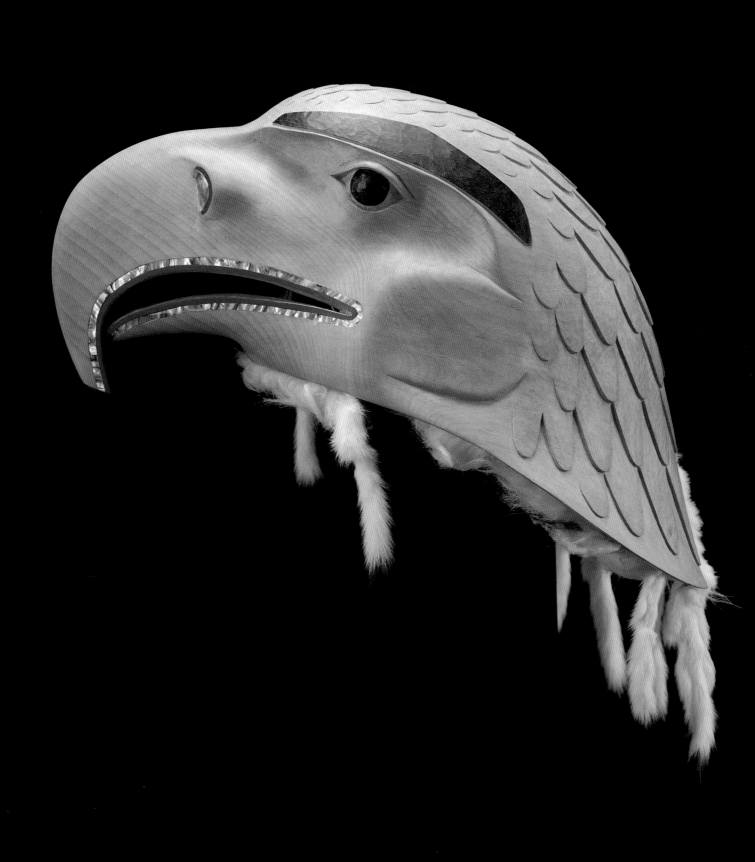

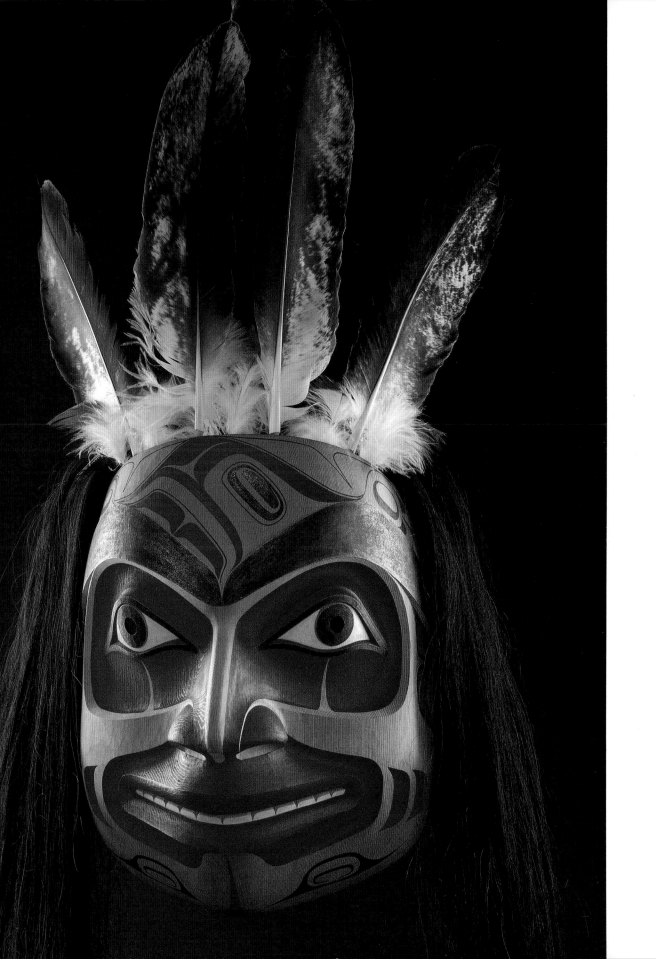

EAGLE HEADDRESS

NORMAN TAIT

(NISGA'A)

ALDER. ABALONE SHELL. PAINT

9" X 17" X 11" (1992)

The Eagle headdress is carved in the shape of an eagle's head and was first used many generations ago. Ermine tails and abalone shells are added to signify the wealth and great power of the chief. Traditionally, the inlay is completed by a chosen and honoured artist, as it is unlucky to finish your own regalia.

When I raised a 55-foot totem pole, *Big Beaver*, in front of the Field Museum in Chicago in 1982, my grandfather Rufus Watts gave me the name "The Grizzly Coming into the Village" and the right to wear this Eagle headdress.

This headdress was carved to honour the raising of the Eagle totem pole in Bushy Park in London, England, on 1 July 1992, for the Royal family. It also honoured the raising of a 55-foot totem pole carved by my brother Alver in Gitwinksihlkw on the Nass River on 17 October 1992.

DAWNING OF THE EAGLE TOO

ROBERT DAVIDSON

(HAIDA)

RED CEDAR. HORSEHAIR. FEATHERS. GRAPHITE. PAINT

13" X 10" X 8" (1989)

This is a portrait of myself becoming who I am. I belong to the Eagle clan. The first Dawning of the Eagle mask was in process when I realized that I still needed time to resolve the image of myself. At the same time I wanted this mask for my solo exhibition at the Inuit Gallery in 1989, so I began this second version.

I feel that exhibitions are the end of important chapters in an artist's life, not only because you are focussed on the work that will be in the exhibition but also because of the internal introspection that you feel as so much of yourself goes into the work. I believe people work very hard to be who they are, and anything else is just pretence or living in denial.

This mask is about blossoming into who I am right now, although the process will continue until death.

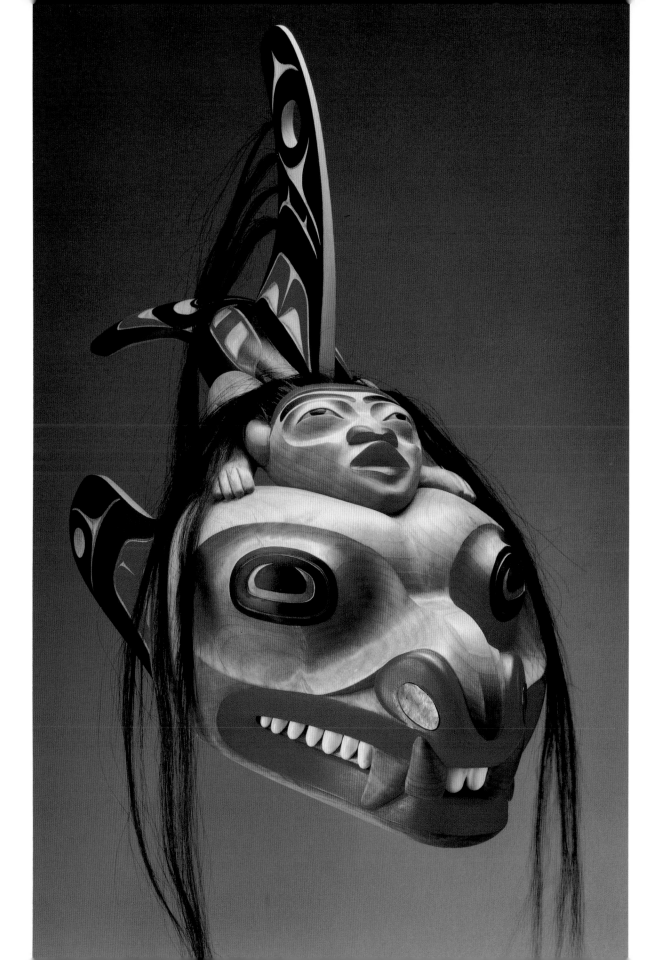

HUMAN EAGLE

DEMPSEY BOB

(TAHLTAN/TLINGIT)

ALDER, HUMAN HAIR, PAINT

10" X 8" X 5" (1989)

KILLER WHALE HEADDRESS

STAN BEVAN

(TAHLTAN/TLINGIT/TSIMSHIAN)

ALDER, OPERCULUM SHELL,

ABALONE SHELL, HUMAN HAIR, PAINT

12" X 20" X 11" (1989)

Tlingit clan crests are always worn on the forehead. The Eagle is one of our main crests. This represents the story of a southern migration of the Eagle clan from northern Alaska.

The Killer Whale headdress is worn by chiefs of the crest at ceremonies. The Killer Whale is one of the subcrests of the Wolf clan of the Tlingit people.

When carving a headdress, I keep in mind the pride and the strength associated with the wearing of these pieces. In this headdress, I wanted the lines to run smoothly through the piece, with a balance between the areas of sculpted wood and the areas that were painted and inlaid.

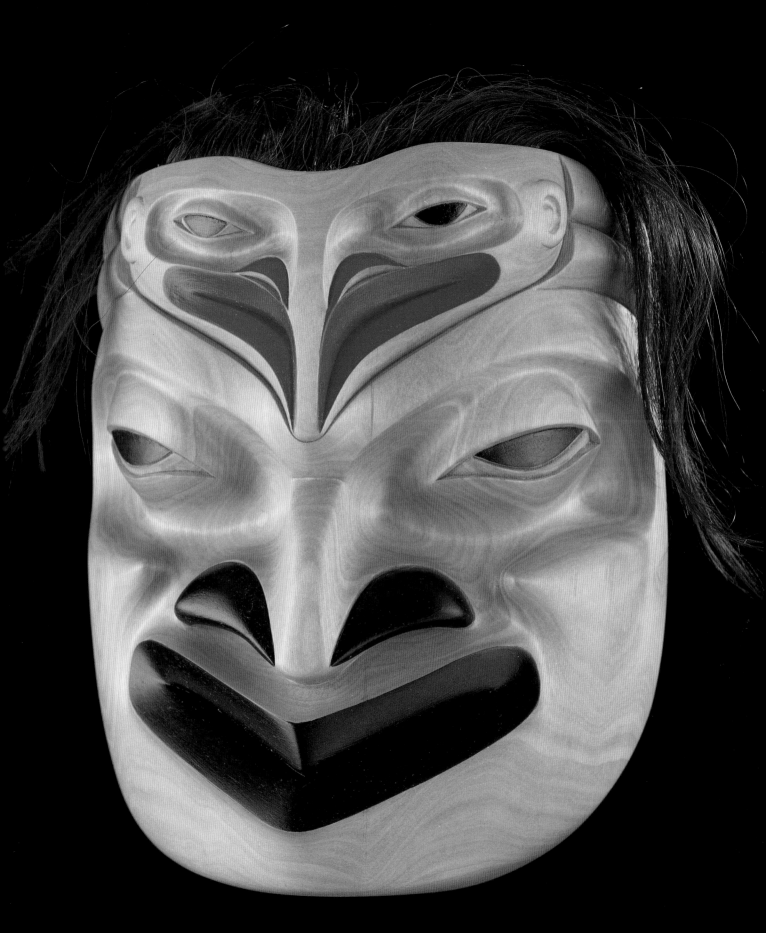

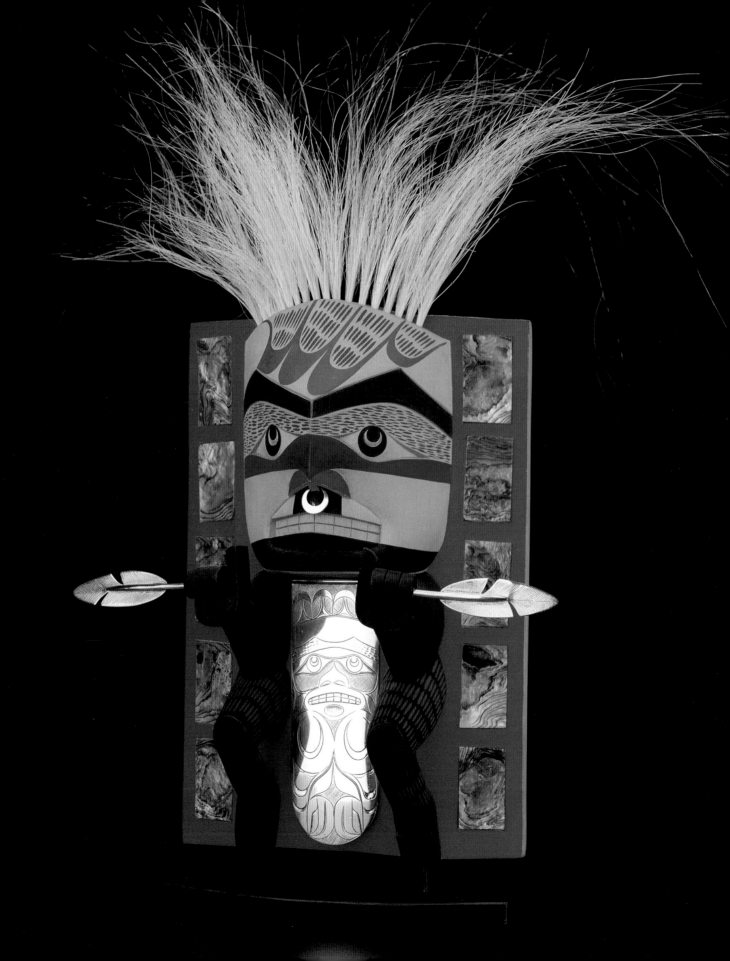

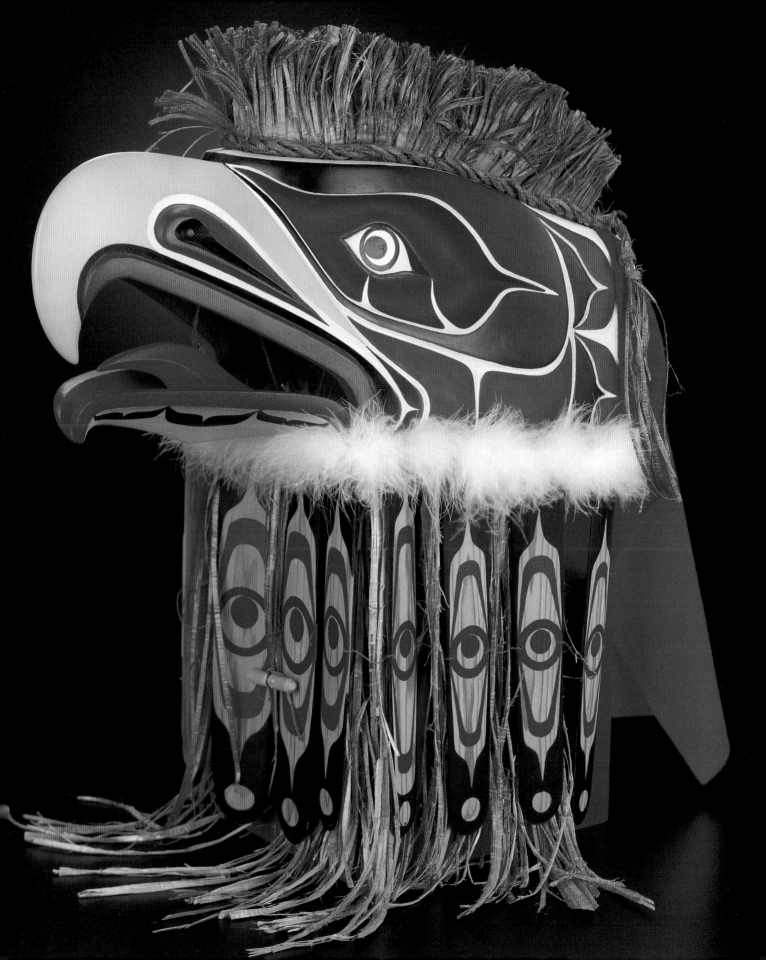

FRONTLET

ART THOMPSON

(NUU-CHAH-NULTH, DITIDAHT)

RED CEDAR, SILVER, ABALONE SHELL,

HORSEHAIR, PAINT

9" X 6" X 3" (1990)

First of all, this particular frontlet was made entirely from my own concepts, based on family history. My family received the rights to use the frontlet from our great-grandmother Nookqwa, whose ancestors came from Clallam Bay, Washington. Through her daughter, my grandmother, this prerogative was passed on to my sister and then passed on to my brother's daughters as well as my own daughters.

Secondly, the figure of the shaman is placed on this frontlet again for my own reason. My family, in its rich history, has had powerful individuals who used natural and supernatural powers for the betterment of the village. With this rich history of shamanism, I felt it appropriate to portray one individual in particular, my great-grandfather Tookbeek. I do not know whether or not one of his powers came from eagle feathers, but I chose to portray him holding two of them in this instance.

EAGLE MASK

GLENN TALLIO

(NUXALK)

RED CEDAR, CEDAR BARK, DOWN,

MELTON CLOTH, PAINT

18.5" X 7" X 9" (1991)

The Eagle in Nuxalk mythology is a creature that is almost as powerful as the Raven. Eagle masks were often carved in conjunction with *sisaok* (ancestral family dance) names and were used in memorial potlatches.

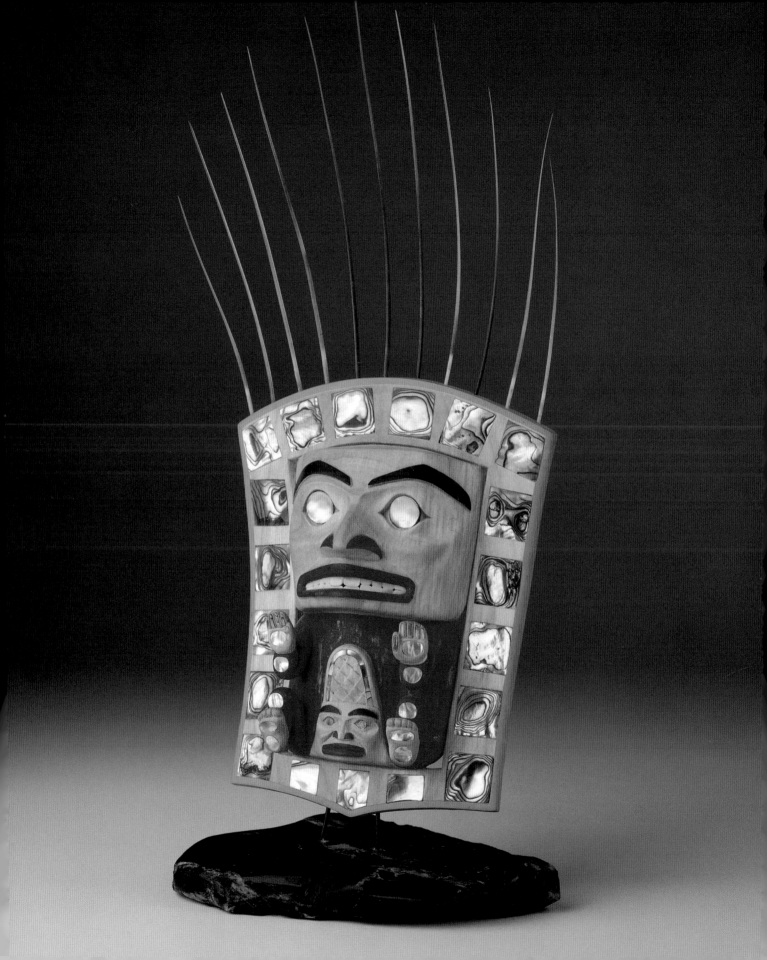

EAGLE HUMAN

DEMPSEY BOB

(TAHLTAN/TLINGIT)

ALDER. HAIR. PAINT

9" X 9" X 4.5" (1989)

BEAVER SPIRIT FRONTLET

NORMAN TAIT

(NISGA'A)

ALDER. ABALONE SHELL. SEA LION WHISKERS. PAINT

7" X 5.5" X 2" (1993)

The Beaver Spirit frontlet indicates, as do all frontlets, the power and position of its owner. The abalone inlays tell of his great wealth. The abalone may be bought, traded or given to the chief at a feast to honour him. A highly skilled and respected carver is chosen to carve and inlay this crown of chiefs. Before the frontlet is worn, it is feasted and given a high-ranking name.

When worn, the frontlet is attached to a hat, with a cape hanging down the back adorned with ermine pelts. The amount of ermine indicates the wealth and power of the chief. The hat is surrounded with sea lion whiskers that point straight up around the head. When there is to be a welcome dance at a feast, a young chief is chosen to wear the frontlet, and the crown of sea lion whiskers is filled with eagle down. A skilled dancer will not empty his crown until he has sprinkled every chief with down.

This mask depicts a human holding onto the Eagle for a journey. The human's hands are in a tight grasp around the Eagle's ears. The eagle is considered a spiritual bird and is respected by our people. Its down and feathers are used in ceremonies to show respect for others.

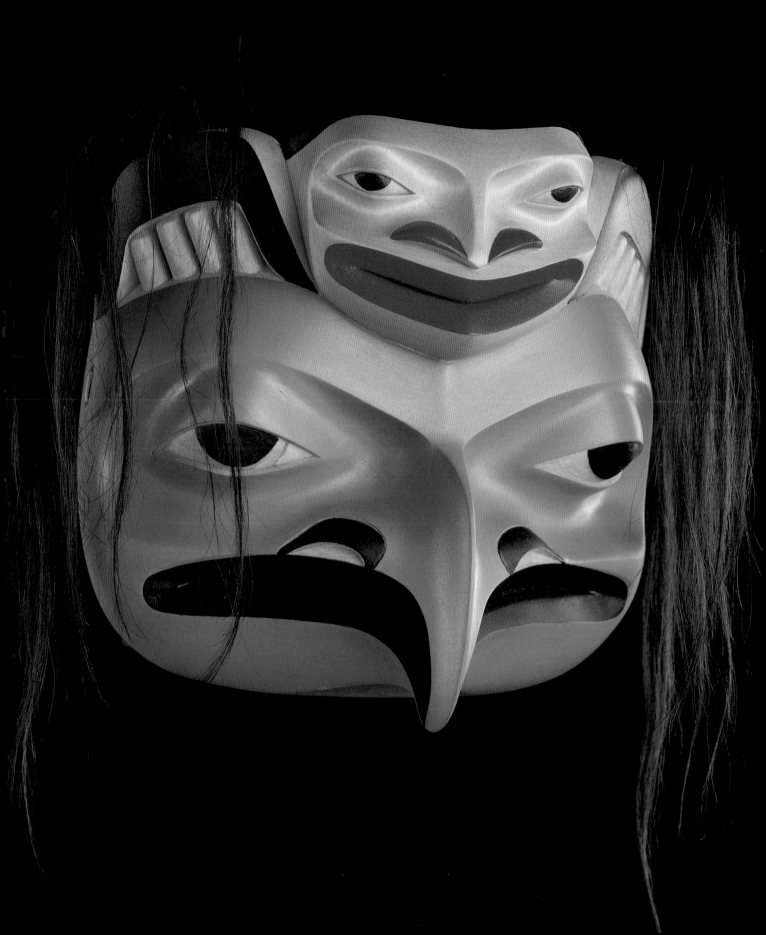

SHAMAN AND TRANSFORMATION MASKS

..

SHAMAN MASKS DEPICT THE ABILITY TO CHANGE SHAPE OR THE JOURNEY TO AND

FROM THE TRANCE STATE. TRANSFORMATION MASKS MAY DEPICT THE ABILITY TO

CHANGE FORM OR THE MINUTE CHANGES THAT A PERSON GOES THROUGH EVERY DAY.

NORTHERN PORTRAIT MASKS ARE CARVED AND PAINTED ASYMMETRICALLY:

THE TRANSFORMATION IS SUBTLY REVEALED AS THE MASK IS SLOWLY ROTATED FROM

THE HEAD-ON VIEW TO PROFILE. OTHER TRANSFORMATION MASKS CONSIST OF AN

EXTERNAL MASK THAT CAN BE SPLIT OPEN TO REVEAL A DIFFERENT FORM INSIDE.

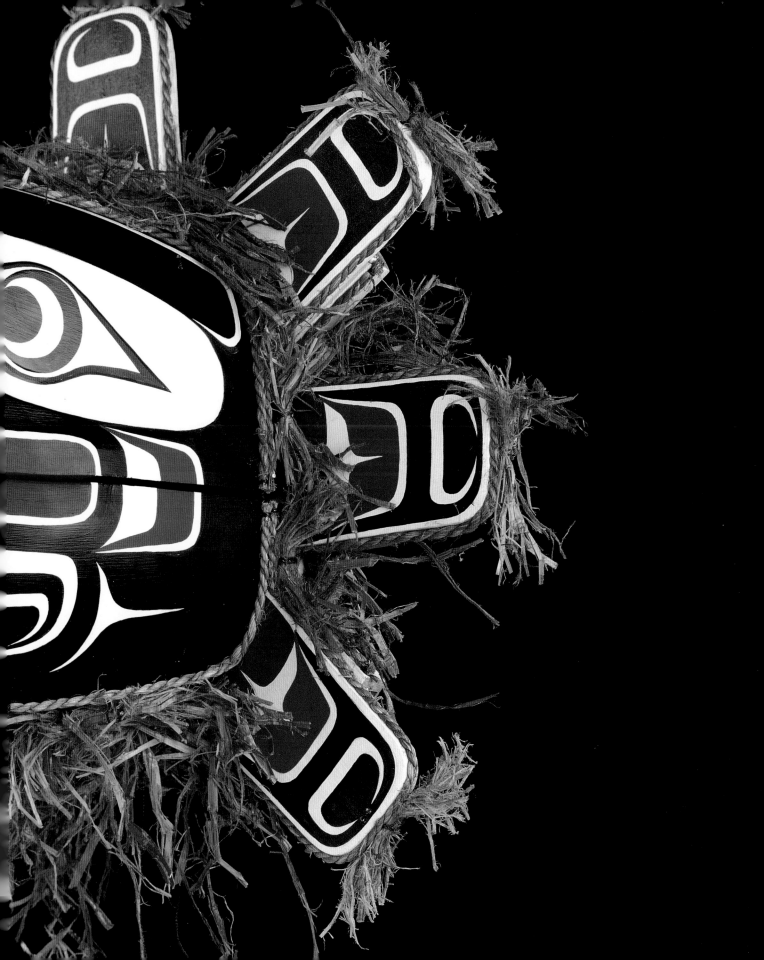

SEA RAVEN/SUN TRANSFORMATION MASK

BEAU DICK

(KWAKWAKA'WAKW)

RED CEDAR, CEDAR BARK,
HINGES, TWINE, PAINT
25" X 26 " X 28" (CLOSED) AND
36" X 36" X 26" (OPEN) (1994)

The Sea Raven is one of the supernatural forms given to Siwidi by K̓umugwe', chief of the undersea, when Siwidi left the undersea. The undersea world is parallel to our world, and this includes the sun, moon and other natural elements as well as natural and supernatural creatures.

The Sea Raven is carved in the monumental style of the cannibal birds of the *hamatsa* ritual. The Sea Raven mask opens up to reveal the form of the Sun. Usually, when the Sun is the inner form of a transformation mask, it is difficult to disguise because the Sun's rays also act as a fulcrum to create the tension in the wires to open the mask. In this case, however, the fins of the Sea Raven are attached to the four sections of its beak, and this creates the tension in the wires; there are no rays to indicate the Sun is inside. In addition, the Sun's face is set back from its rays, which makes it more dramatic-looking than if the rays were coming out from around its face.

The northern style of painting the mask is a reference to the northern legend about Raven stealing the light. This northern influence comes through my marriage to Pam Bevan, which passes on rights and responsibilities to myself and our children, so I have been trying to include northern references in my work.

Eugene Isaac gave me technical assistance on this mask.

PAGES 104/105

SEA RAVEN/SUN
TRANSFORMATION MASK (CLOSED)

SEA RAVEN/SUN
TRANSFORMATION MASK (OPEN)

106

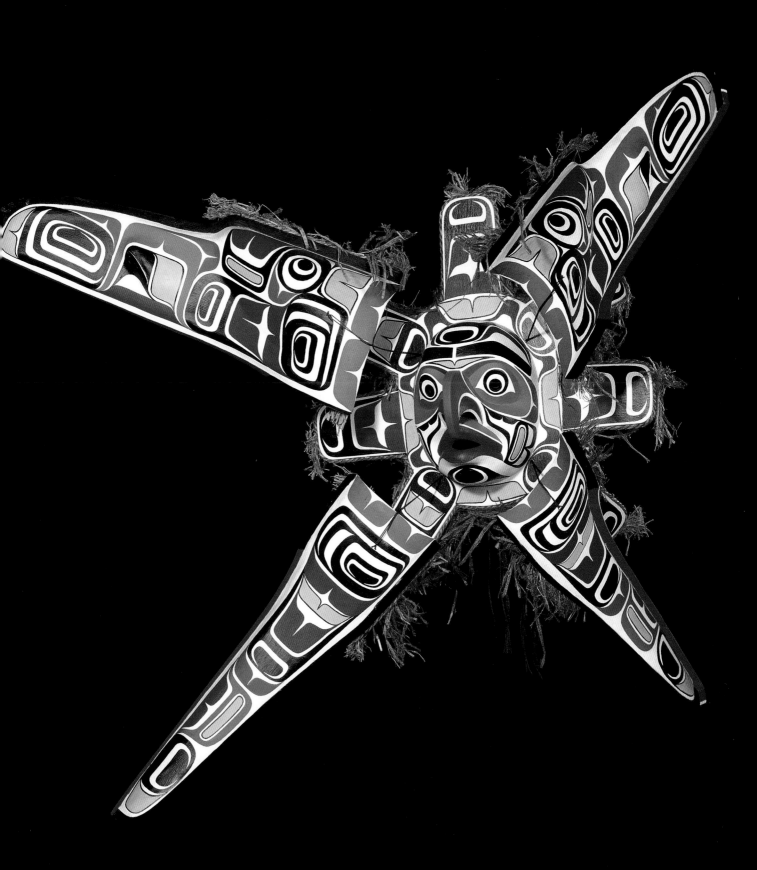

RAVEN CHILD

JOE DAVID
(NUU-CHAH-NULTH, CLAYOQUOT)
ALDER, FEATHERS, CEDAR BARK, BEAR FUR, PAINT
11" X 8" X 6" (1993)

The source for this mask is a northern legend that has many versions. It tells of Raven transforming into a young boy to steal the light and put it into the sky. The consequence of this event was a great altering of the world.

I have done many versions of this legend, because it lends itself to so many aspects of design, narration, transformation and consequence. This particular mask shows Raven as a young boy. His wisdom and alter ego as Raven are hinted at but still disguised.

RAVEN CHILD

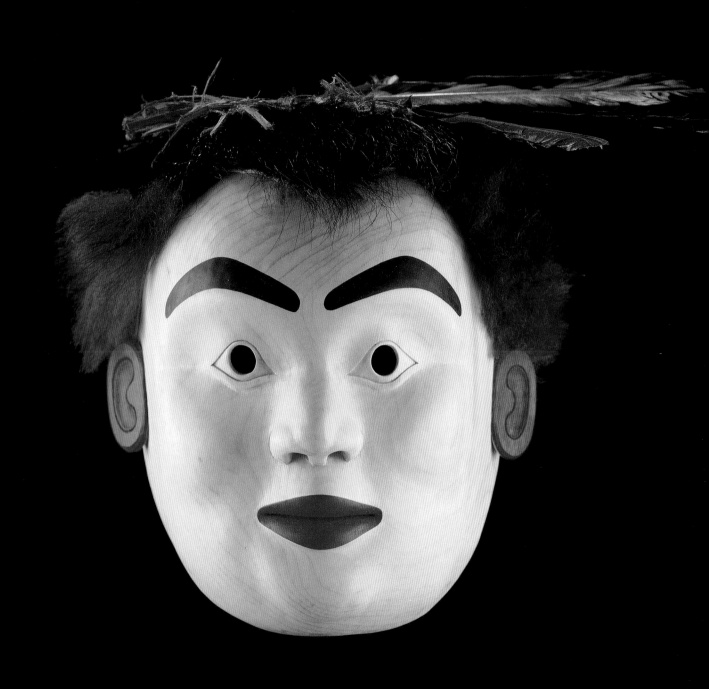

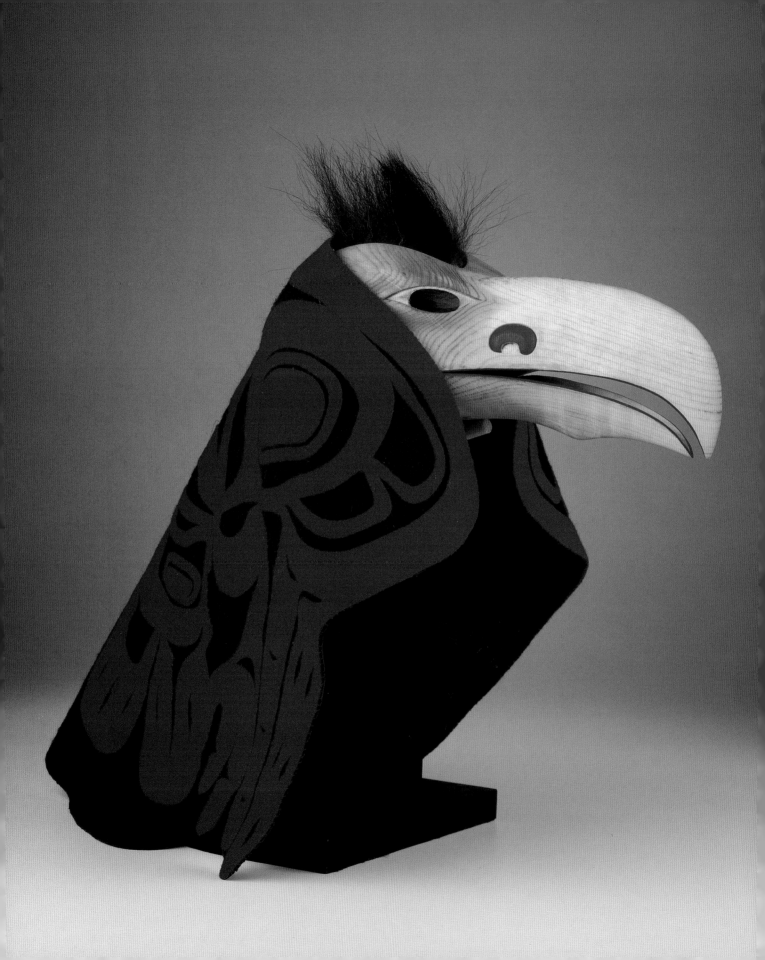

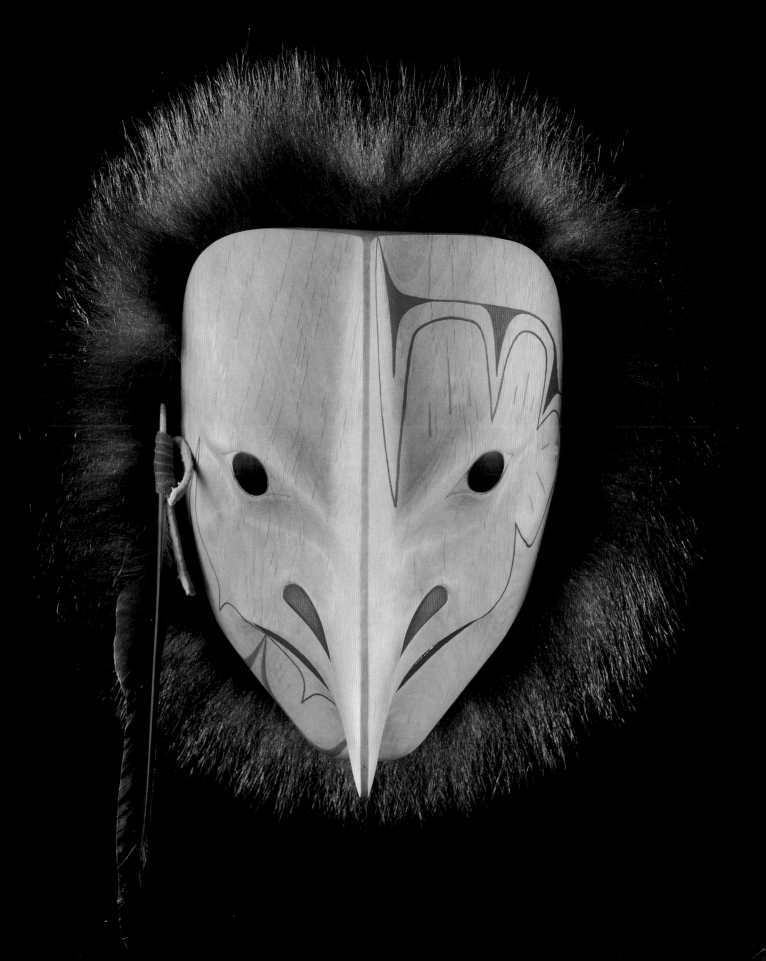

SHAMAN IN A TRANCE

NORMAN TAIT

(NIS<u>GA</u>'A)

ALDER, HORSEHAIR, OPERCULUM SHELL, ABALONE
SHELL, EAGLE DOWN, PAINT
24" X 20" X 13" (1991)

RAVEN HEADDRESS

KEN MCNEIL

(TAHLTAN/TLINGIT/NIS<u>GA</u>'A)

ALDER, BEAR FUR, MELTON CLOTH, PAINT
7" X 11" X 5" (1993)

RAVEN MASK

KEN MCNEIL

(TAHLTAN/TLINGIT/NIS<u>GA</u>'A)

ALDER, BEAR FUR, FEATHERS, PAINT
11" X 8" X 7" (1992)

The Raven clan is one of the two principal Tlingit clans. Many houses are represented by the Raven, so the mask representing a specific house needs to be unique and individual. Forehead masks are worn by the head of the clan at ceremonies.

In all my animal masks, I attempt to capture an essence of the animal with a humanlike expression that might be familiar to that animal. Trying to capture a transformation is like trying to capture a dream. Transformation is about change, just as innovation is part of an artist's style. Trying to push the transformation without losing the essence of the original form is one of the bases of my art.

The key to every mask is to give it life. You have to see the piece breathe, you have to feel it is alive.

The shaman is a medicine man with powers that enable him to transport himself into the spirit world when he is in the process of healing a sick person or to retrieve a medicine spirit for his own use. His powers are symbolized by goat horns or a grizzly claw crown. This crown also implies sexual power. A chief whose wife has yet to bear a son will ask the shaman for help.

The shaman will go into a trance and dream of a small canoe. In his trance, he will enlarge this canoe until it is big enough to carry all his great medicines. He will then climb into the canoe and paddle to the spirit world. When he finds the well spirit, he sucks it into his body and paddles back to the sick person. He will blow the well spirit into the sick person and suck out the bad spirit. He will then go back into his trance and paddle back to the spirit world to blow the bad spirit out.

The down on the tip of the horns is taken from an eagle's nest. This enhances the shaman's power to return to the spirit world. It also indicates that he will not use his powers for harmful purposes. The faces are the spirits of ancestral shamans from whom he has inherited his powers.

PAGE 110
RAVEN HEADDRESS

PAGE 111
RAVEN MASK

SHAMAN IN A TRANCE

112

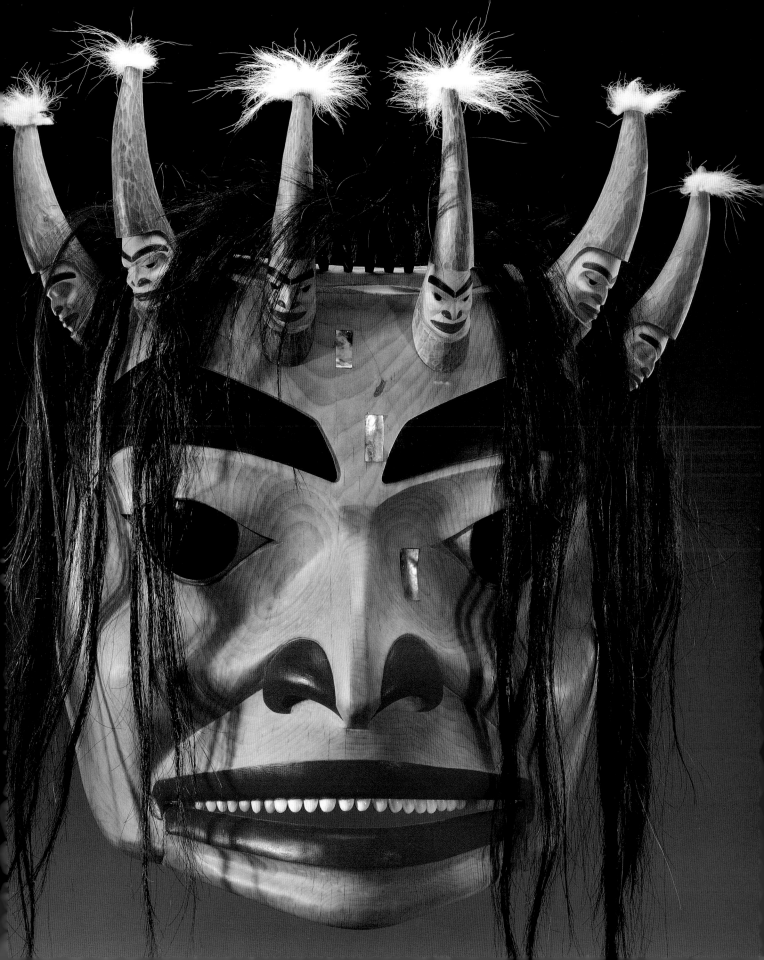

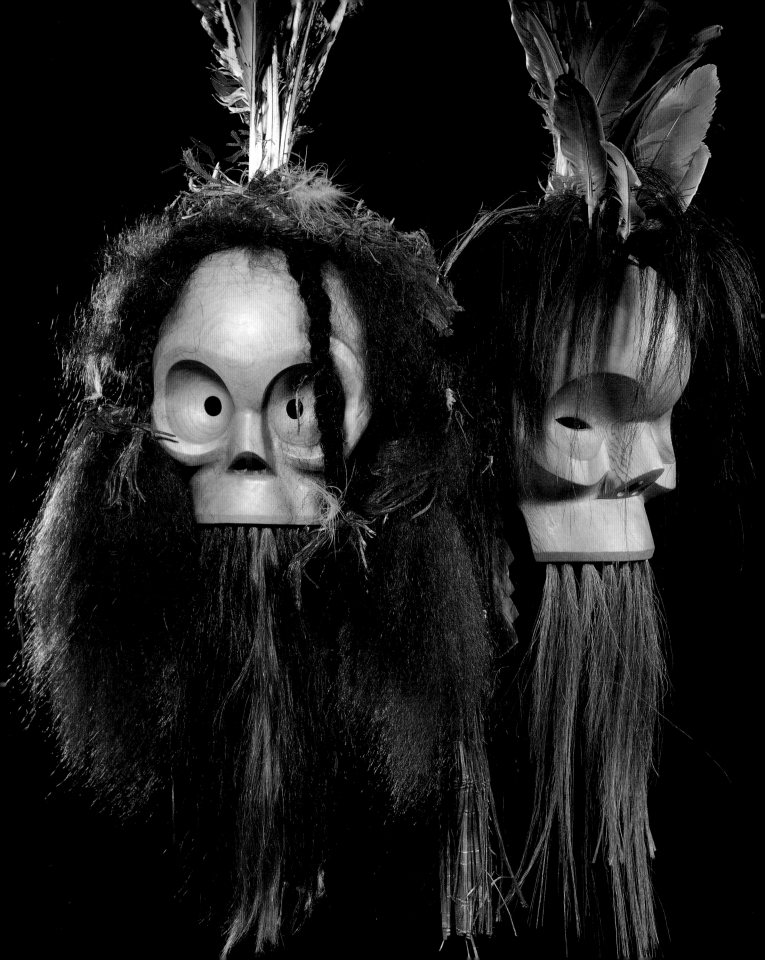

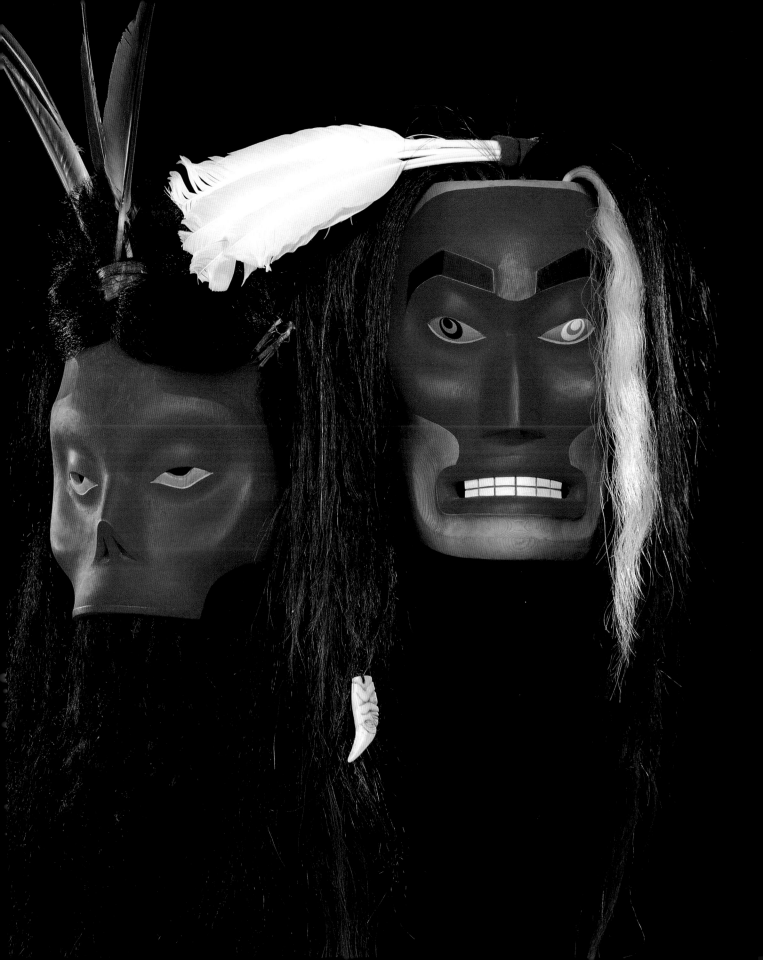

SORCEROR MASK

JOE DAVID
(NUU-CHAH-NULTH, CLAYOQUOT)
RED CEDAR, HORSEHAIR, FEATHERS,
DOWN, CEDAR BARK
38" X 8" X 7" (1990)

This series of four masks comes from tales told in many native cultures about reduction to a common element and rebuilding on this form to become something else. The idea of reaching death as an extreme and then returning to life implies a journey where power and knowledge have been gained. Spiritual journeys are often made into the past in search of power and knowledge.

Many of my images are amoral and allow society to make judgements based on its definition of morality. For example, a hundred years ago, this mask would have been judged by very different standards, and a hundred years from now the judgements will be decidedly different again.

SHAMAN RETURNING

JOE DAVID
(NUU-CHAH-NULTH, CLAYOQUOT)
RED CEDAR, HORSEHAIR, FEATHERS
35" X 16" X 11" (1990)

This mask is the second stage of the shaman in transformation between life and death. The first mask in the series was treated to give it a skeletal patina, but this one I left alone and allowed the patina to form naturally. I was pleased to see this mask again years later, when this process had given the mask a life of its own.

SHAMAN RETURNING

JOE DAVID
(NUU-CHAH-NULTH, CLAYOQUOT)
RED CEDAR, HORSEHAIR, ARTIFICIAL HAIR,
FEATHERS, PAINT
38" X 8" X 7" (1990)

The first pulse of life with its rush of blood leaves no question that life has returned.

SHAMAN RETURNS

JOE DAVID
(NUU-CHAH-NULTH, CLAYOQUOT)
RED CEDAR, HORSEHAIR, FEATHERS, PAINT
11" X 8" X 7" (1990)

This mask is meant to question the intent of the shaman following his return to life. The one eye being a different colour could indicate a person born with supernatural power. I wanted a real power piece because those who view this mask may question the intent of the shaman for undergoing the death-life cycle to demonstrate his power.

PAGE 114
SORCERER MASK (LEFT) AND SHAMAN RETURNING (RIGHT)

PAGE 115
SHAMAN RETURNING (LEFT) AND SHAMAN RETURNS (RIGHT)

BAKWAS/GROUSE

116

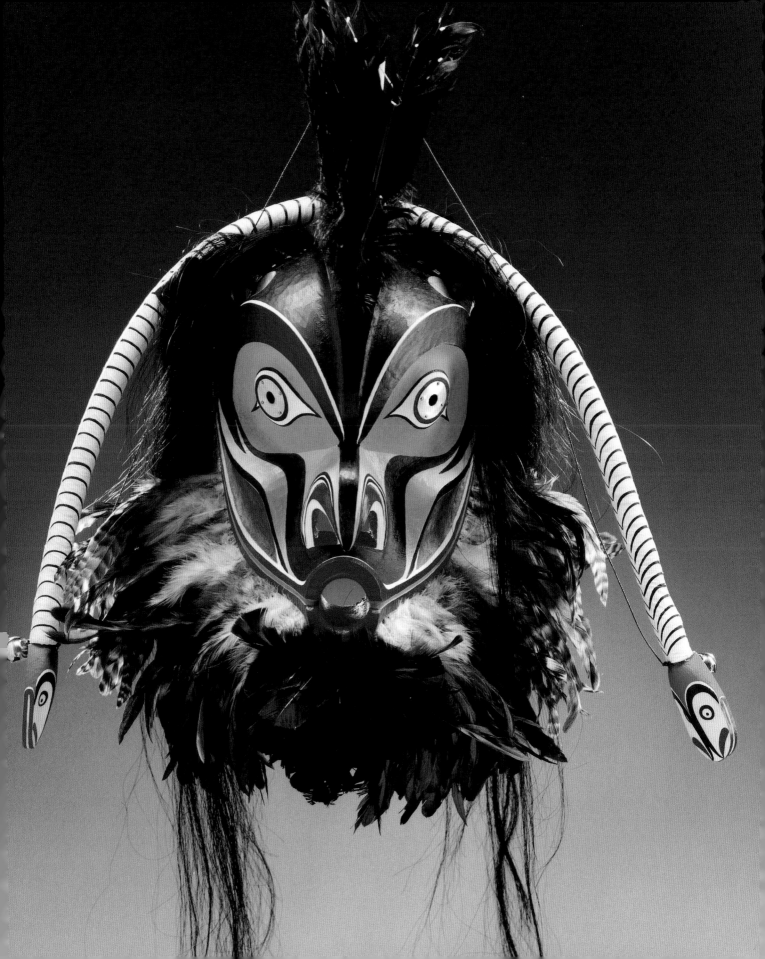

GAGIID

REG DAVIDSON

(HAIDA)

RED CEDAR, HORSEHAIR, OPERCULUM SHELL, PAINT

15.5" X 15" X 9.5" (1988)

BAKWAS/GROUSE

WAYNE ALFRED

(KWAKWAKA'WAKW, NIMPKISH)

RED CEDAR, FEATHERS, CLOTH,

BINDING CORD, PAINT

23" X 9" X 9" (1989)

This is based on one of the masks returned from the Canadian Museum of Civilization in Hull, Quebec, to the U'mista Cultural Centre in Alert Bay in 1982. The return of the cultural property followed an agreement to build a museum to house the collection.

This particular mask was labelled as a *bakwas* (wild man), but I also see a *sisiutl* (double-headed supernatural sea serpent). I also think that this is a grouse because of the big round eyes and feathers. All of these forms are transforming; therefore, any of these interpretations may be correct.

A *gagiid* is a person who almost drowns but is strong enough to survive the hypothermia. He struggles ashore and lives on the sea life that he can harvest from the shore. Being crazed, he bites into sea urchins and red snappers, both of which are covered with spines, and these protrude from his mouth because he devours his food frantically. In the old stories of *gagiid* he grows thick hair and, in some cases, learns to fly. You should not make fun of the *gagiid* in any way or else he will come after you.

I have danced the mask of this character many times, and after being the *gagiid* I began to have a succession of dreams about this character. In each dream I am chasing him, trying to see his face. From behind, I can see that he is covered with thick black hair, which is true to the historical sightings of *gagiid*. In my dream, he also has a long tail. When he finally reveals his face, he has features that are both moose and human.

The dance of *gagiid* is done in two stages. The first part is when he is in a totally wild state, and everyone present is shocked and filled with fear at seeing him. The second part is when he is captured with a cedar bark rope and eventually tamed and returned to his human state.

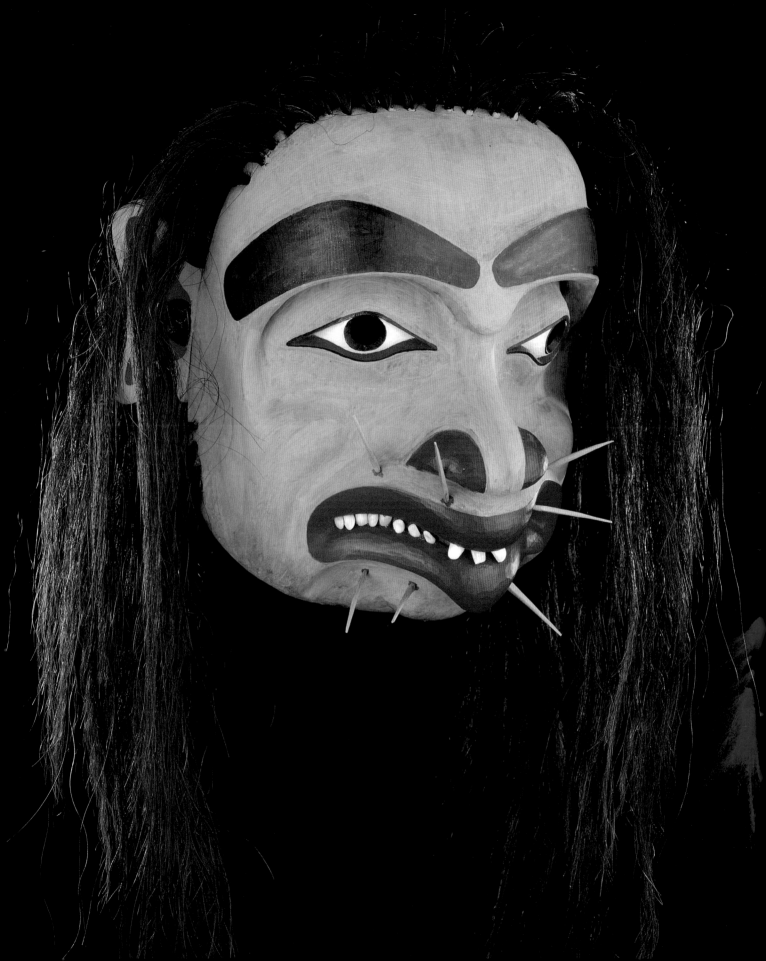

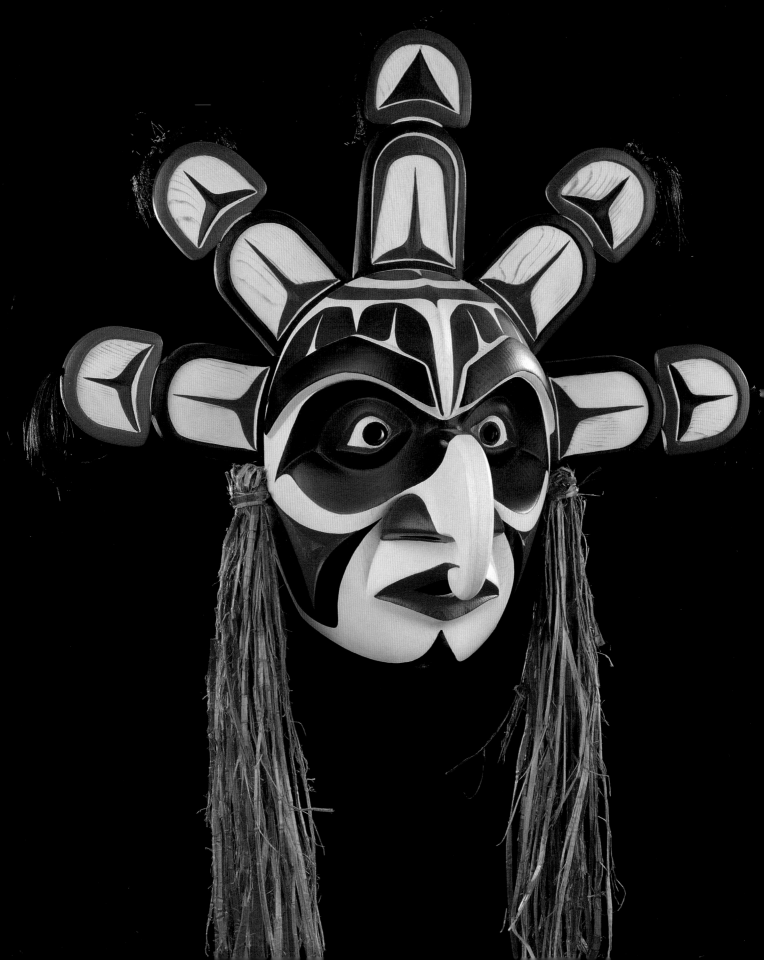

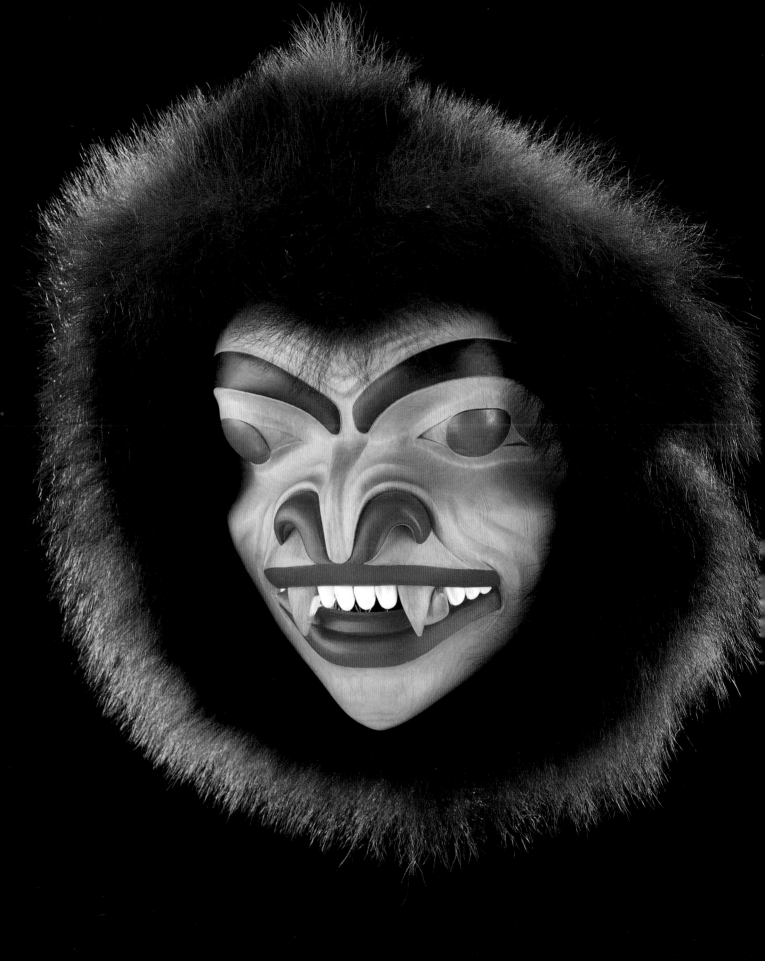

BEAR/HUMAN TRANSFORMATION

KEN MCNEIL

(TAHLTAN/TLINGIT/NISGA'A)

ALDER, COPPER, BEAR FUR, OPERCULUM SHELL, PAINT

14" X 13" X 8" (1987)

SUN/HAWK MASK

GLENN TALLIO

(NUXALK)

RED CEDAR, CEDAR BARK, PAINT

20" X 20" X 9" (1991)

The Sun, Moon and other natural elements are central Nuxalk crests, and therefore there are many stories connecting families to the Sun. All masks that tell family stories are displayed during a four-day period within the *sisaok* (ancestral family dance rituals). The source and ownership of each mask is declared as it is presented.

This mask represents a member of the Grizzly Bear clan. The challenge of this mask is to maintain the balance between the features of both the Bear and the human.

Clan masks are worn to document the ownership and rights of the clan at ceremonies both inside and outside the clan's boundaries. A mask such as this will be a bold statement so that the owner of the crest will be remembered when the mask is presented in the future.

PAGE 120

SUN/HAWK MASK

PAGE 121

BEAR/HUMAN TRANSFORMATION

THE KEEPER OF DROWNED SOULS

122

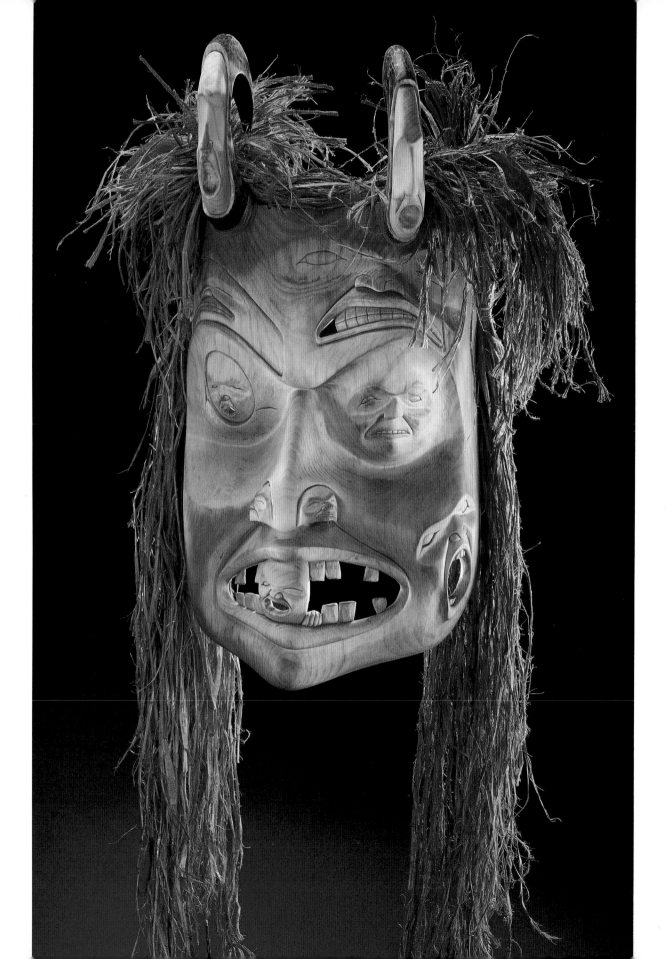

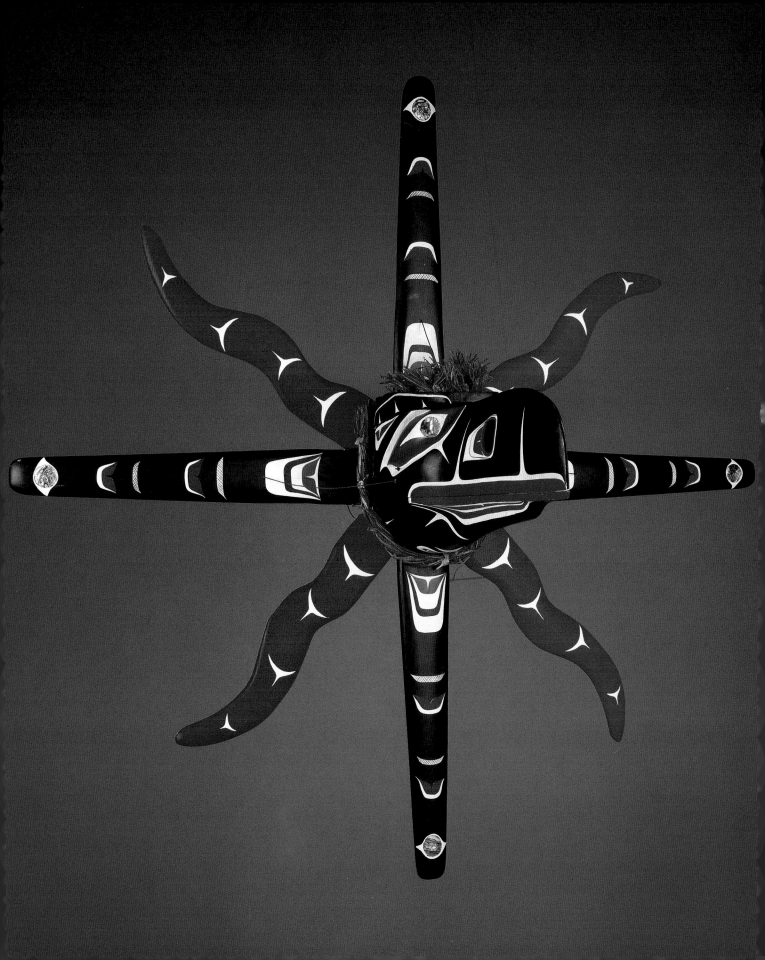

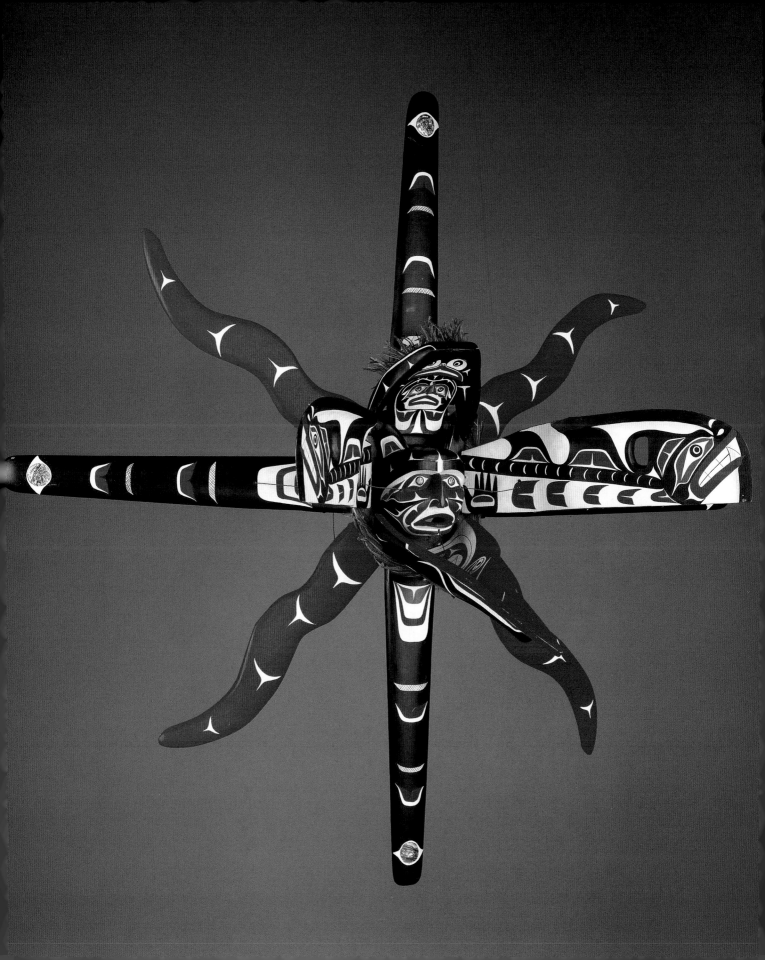

THE KEEPER OF DROWNED SOULS

RON TELEK
(NISGA'A)
ALDER, CEDAR BARK
24" X 12" X 9" (1990)

The Keeper of Drowned Souls is a devourer of spirits as well as of souls. He replenishes his power and strength by combing the oceans for those who have drowned. He will also entice or trick his human prey into the water by transforming into a sea creature or even into human form. His most common forms are the octopus, shark or a large whale, because they can capsize or overpower canoes and drag people to the bottom of the ocean, where he can take away their spirits.

The horns represent two soulless men whom the Keeper torments by displaying them on his head. The faces in the circle eye, the brow and nostrils are souls in torment. The man in the mouth is alive but in the process of being dragged to his death. The three grimacing faces are disguises of devoured men that the Keeper uses to trick other men into the water.

RAVEN SUN TRANSFORMATION MASK

MARVEN TALLIO
(NUXALK)
RED CEDAR, CEDAR BARK, TWINE, HINGES, PAINT
55" X 55" X 22" (1992)

This is Raven proving that he can transform into different beings, in this case both the sea serpent *sisiutl* and human form. The exterior mask is Raven and Sun, which is the story of Raven bringing light to the world. It opens to reveal the interior mask of the *sisiutl*, both in the central human face flanked by the two heads extending into the rays, and in the top where the *sisiutl* is in the process of taking over a human soul.

The Nuxalk people divide the world into five realms rather than the more usual earth, water and sky. The *sisiutl* lives in the second realm, in a salt-water pond, as the pet of the female deity of the *hamatsa* ritual. People who die and go to this place do not return to the natural world.

The bottom jaw of the mask represents another Raven story about the source of the salmon. There are several versions of this particular story that attribute the original ownership to either the Mink or the Crane. Raven steals the salmon eggs, and in his greed takes more in his beak than he can possibly carry. As Raven struggles to fly with this heavy and awkward cargo, the eggs fall into the rivers and streams, giving the world yet another precious gift.

THE JOURNEY

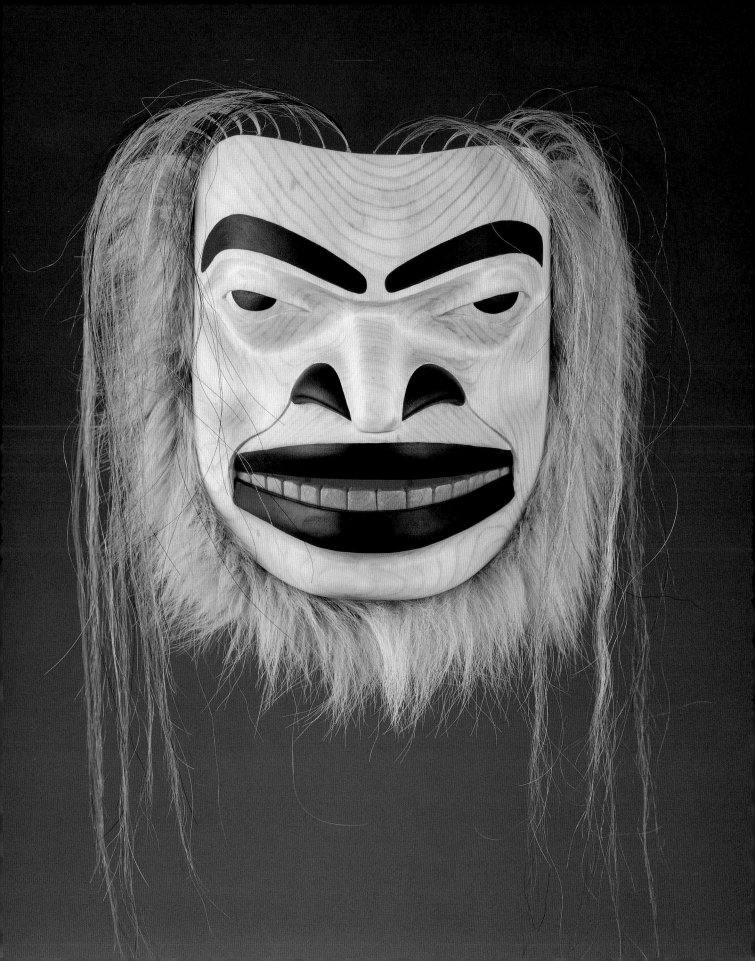

RESIDENTIAL SCHOOL TRANSFORMATION MASK

DAVID NEEL

(KWAKW<u>AKA</u>'WAKW)

RED CEDAR, FEATHERS, CEDAR BARK, PAINT,
HINGES, TWINE

14" X 10" X 8" (CLOSED)
AND 35" X 37" X 9" (OPEN) (1990)

THE JOURNEY

STAN BEVAN

(TAHLTAN/TLINGIT/TSIMSHIAN)

ALDER, WOLF PELT, HORSEHAIR, PAINT

10" X 9" X 6" (1993)

Masks depicting both animal and human features, or human and natural elements, are often about the process of transforming from one form to another.

In this mask, I wanted to capture a journey between two spaces which may not be the spirit world or the real world, but a space or time of transformation.

The residential school system was created by governments and churches to assimilate native people into mainstream society, as co-existence between the two was considered impossible. Children were taken away from their families and placed in far away residential schools to learn non-native ways. It was felt that complete assimilation could be accomplished in one or two generations by separating the children from their culture.

The tragic legacy of this program is still strongly felt. Many native people now in their forties are the product of the residential schools, where they experienced physical and sexual abuse. These survivors are now in the position of being parents themselves, with no positive family values to draw on. Some escaped the system and went to larger urban centres only to find hardship on the streets. Native groups across Canada are now fighting for compensation for the injustices of the residential school program.

This mask depicts the child transforming into an adult. The experiences of the school are clearly shown on the face of the child. The Catholic and Protestant churches are represented in the motif inside the mask. The adult is a strong figure depicted in traditional Kwakw<u>aka</u>'wakw lines, reinforcing the fact that the residential school program failed.

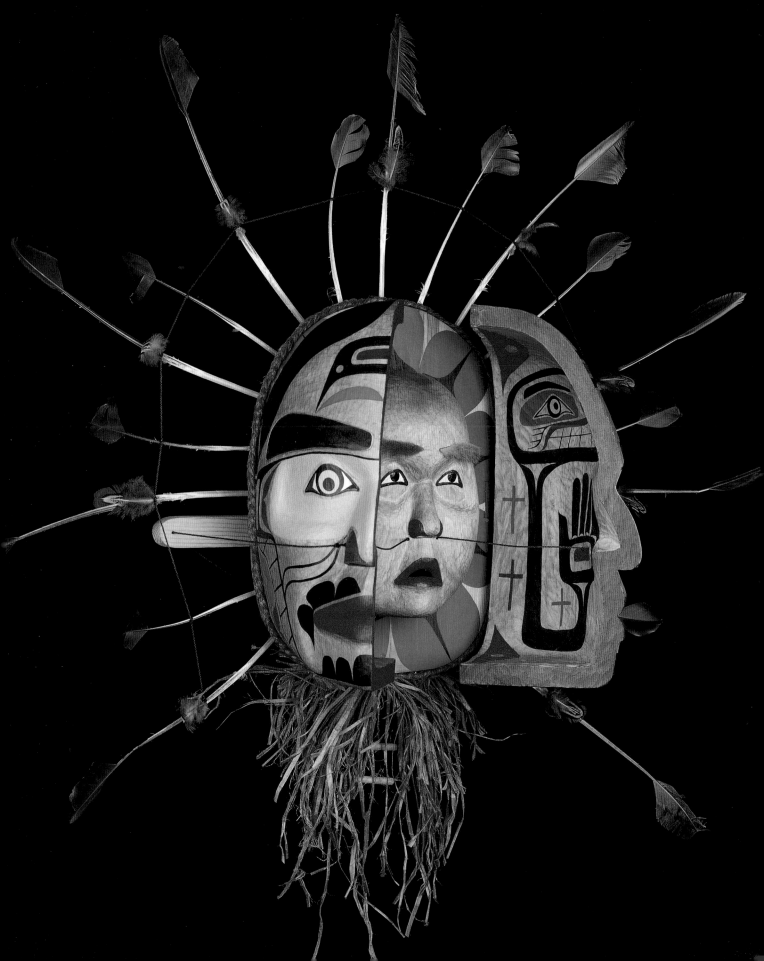

BRUCE ALFRED (BORN 1950)

Bruce Alfred studied with Richard Hunt and Doug Cranmer, assisting Cranmer on several projects, including the Kwakwaka'wakw big house for the Canadian Museum of Civilization in Hull, Quebec. He has produced many ceremonial pieces and worked on the housefront for the U'Mista Cultural Centre in Alert Bay, the restoration of the Alert Bay Big House designed by Ben Dick and the restoration of the Wa'kas pole in Stanley Park, Vancouver.

WAYNE ALFRED (BORN 1958)

Wayne Alfred apprenticed with Beau Dick and assisted him on many projects, including a totem pole for Stanley Park in Vancouver. Wayne studied Kwakwaka'wakw community styles, which are still evident in his work, an adaption of historic subjects to contemporary themes and issues. He is also a talented dancer who takes part in ceremonies and cultural events, and his understanding from the perspective of a performer has influenced his work as an artist.

STAN BEVAN (BORN 1961)

Stan Bevan studied at the Gitanmaax School of Northwest Coast Art in Hazelton and apprenticed under his uncle Dempsey Bob, working on numerous commissions with him. He has also collaborated with his cousin Ken McNeil, including carving four crest poles for the Mukskum-ol housing group in Terrace and a totem pole to represent Canada at Expo 92 in Seville, Spain. Stan has established a reputation as a strong, innovative carver.

DEMPSEY BOB (BORN 1948)

Demsey Bob studied with Freda Diesing and later attended the Gitanmaax School. His totem poles stand in London, England; Ketchikan, Alaska, and San Francisco. His work is in the Smithsonian Institution, National Museum of Ethnology in Osaka, Japan; Museum of Ethnology in Hamburg, Germany; Canadian Museum of Civilization; Royal British Columbia Museum; University of British Columbia Museum of Anthropology, Vancouver.

JOE DAVID (BORN 1946)

Joe David studied commercial art before investigating Northwest Coast art. His spiritual knowledge of Nuu-chah-nulth culture as well as of other native cultures influences his work. Many of his images document significant events in his life. In 1981 he was adopted by Haida artist Robert Davidson, an honour reciprocated ten years later when Robert was adopted by the David family. Joe David's work is in museum and private collections internationally.

REG DAVIDSON (BORN 1954)

Reg Davidson apprenticed under his brother Robert, helping to carve the Charles Edenshaw Memorial Longhouse and numerous monumental sculptures. In 1980, he joined the Rainbow Creek Dancers, a group dedicated to performing Haida songs and dances, and is their principal dancer. He works in wood, precious metal and graphics. His major commissions include a totem pole for Tamagawa University in Japan and a pole commissioned by his father and raised in Massett.

ROBERT DAVIDSON (BORN 1946)

Robert Davidson is a leading contemporary artist, working in wood, graphics, precious metals and bronze. His major commissions include a totem pole for the Maclean-Hunter building in Toronto, Ontario, and three totem poles and a bronze sculpture for the Pepsico International Sculpture Park in Purchase, New York. He has been in many group and solo exhibitions, including a major retrospective, "Eagle of the Dawn," at the Vancouver Art Gallery in 1993 and the Canadian Museum of Civilization in 1994.

BEAU DICK (BORN 1955)

Beau Dick has produced numerous pieces for ceremonies and has been in many major exhibitions. His distinctive style balances the powerful and theatrical Kwakwa̲ka'wakw way of carving with painting that blends traditional formline design and a finger-rubbed finish. The transformation mask he created for Expo 86 in Vancouver is now in the Canadian Museum of Civilization. The same year, he carved a totem pole for Stanley Park.

FREDA DIESING (BORN 1925)

Freda Diesing was one of the people instrumental in the renaissance of Northwest Coast art. Many artists in this collection have acknowledged her as a major influence, as both a teacher and artist. She began her own career as one of the first students of the Gitanmaax School and later held numerous positions there. Her work is widely collected, and she continues to pursue carving as well as painting and jewellery.

TONY HUNT JR. (BORN 1961)

Tony Hunt was one of the first contemporary artists to be trained traditionally through an apprenticeship with his father, Tony Hunt Sr. His work was featured in the "Chiefly Feasts" catalogued exhibition, which opened at the Museum of Natural History in New York in 1993. He is also culturally active and has participated in numerous ceremonies as a talented dancer. His work is in major museums as well as corporate and private collections internationally.

ROBERT JACKSON (BORN 1948)

Robert Jackson attended the Gitanmaax School and has studied the Gitksan portrait mask, which combines abstract carved and painted designs on human and animal forms. His work is in museum and private collections, including the University of British Columbia Museum of Anthropology and the Royal British Columbia Museum. One of his model totem poles was presented to the Duke of Edinburgh, and one of his headdresses to Prime Minister Pierre Trudeau of Canada.

KEN MCNEIL (BORN 1961)

Ken McNeil apprenticed under his uncle Dempsey Bob and assisted him with a number of commissions. He has also collaborated with his cousin Stan Bevan to produce monumental commissions, including four totem poles for the Muks-kum-ol housing group in Terrace, British Columbia; a totem pole at Expo 92 in Seville, Spain, and a carved house post for the Native Learning Centre at the University of British Columbia. His bold masks also show a strong attention to detail.

EARL MULDOE (BORN 1936)

Earl Muldoe attended the Gitanmaax School and was the artist who designed and oversaw the building of the 'Ksan village in Hazelton and was the master carver for the Gitanyow and Gitsegukla village totem pole restoration and replication project. His numerous totem poles include one for the Seattle Center in Seattle, Washington; one in Edmonton, Alberta, and five for the Highfield Corporation in Richmond, British Columbia. As well, he carved wall murals for the Parliament Buildings in Ottawa, the Royal Bank building in Vancouver and the Thunder Bay Museum in Thunder Bay, Ontario.

DAVID NEEL (BORN 1960)

David Neel studied photography at Mount Royal College in Calgary and the University of Kansas. He began studying his native heritage from the perspective of a photographer and published a book, *Our Chiefs and Elders*, about prominent Northwest Coast elders. He has also created a series of masks on contemporary issues, which continue to be a focus of his work in photography, graphics and sculpture.

TIM PAUL (BORN 1950

Tim Paul apprenticed with Ben Andrews, John Livingston, Richard Hunt and Art Thompson. In 1977 he became the assistant carver at the Royal British Columbia Museum and senior carver in 1984. His totem pole commissions include the Canadian Museum of Civilization; Auckland, New Zealand; the Southwest Museum in Pasadena, California, and Yorkshire Sculpture Park, England. His understanding of Nuu-chah-nulth culture contributes greatly to his work.

TERRY STARR (BORN 1951

Terry Starr worked with Richard Hunt and Tim Paul at the Royal British Columbia Museum and assisted Richard Hunt in carving a totem pole for Expo 88 in Brisbane, Australia. He is interested in his own Tsimshian style, which he has continued to redefine. He created a Tsimshian longhouse for the Canadian Museum of Civilization and another for Port Simpson, British Columbia. He also works in graphics.

NORMAN TAIT (BORN 1941)

Norman Tait studied flat design with Freda Diesing and Gerry Marks in 1973 before investigating his own tribal art. He has produced numerous totem poles, including one, *Big Beaver*, for the Field Museum in Chicago; one privately commissioned and donated to the Heard Museum in Phoenix, Arizona, and one for the British Royal family, erected in Bushy Park, London, in 1992. In addition to being a carver, he works in precious metals and graphics.

GLENN TALLIO

Glenn Tallio has produced numerous pieces for potlatches and feasts, a responsibility he takes seriously and accepts willingly. His dedication and personal interpretations of traditional Nuxalk style have established him as a leading artist, and he is in demand to produce pieces for museum collections. Glenn was the project manager for the Nuxalk longhouse in the Canadian Museum of Civilization.

MARVEN TALLIO (BORN 1966)

Marven Tallio began carving as a boy under the direction of his father, Glenn. He inherited tribal responsibilities from both sides of his family and has produced many pieces for ceremonial use. Marven was commissioned to create a transformation mask for the Canadian Museum of Civilization and assisted his father in creating the Nuxalk longhouse at the same museum.

RON TELEK (BORN 1962)

Ron Telek apprenticed with his uncle Norman Tait and his work has been strongly influenced by him. He has also worked on numerous totem pole commissions with Norman Tait. While Nisga'a style remains a constant element in his work, he has developed a radical new imagery that deals with the psyche and the unconscious, based on shamanism and transformation.

ART THOMPSON (BORN 1948)

Art Thompson was encouraged by his grandmother to learn about his cultural heritage and art after being injured in a logging accident. He studied at the Vancouver School of Art and Camosun College in Victoria and began to take part in Nuu-chah-nulth ceremonial life. His earliest prints set a standard for Northwest Coast graphics, and he is one of the most accomplished designers, as is evident in his graphics, jewellery and sculpture. He is represented in many museum, corporate and private collections.

LYLE WILSON (BORN 1955)

Lyle Wilson works in the Haisla style, which is often referred to as northern Kwakwaka'wakw, though it is unique, with Kwakwaka'wakw and Tsimshian traits as well as its own. He grew up watching his uncle Sam Robinson carve and studied at the University of British Columbia and Emily Carr College of Art and Design in Vancouver. He is both a curator and artist in residence at the University of British Columbia Museum of Anthropology.

DON YEOMANS (BORN 1958)

Don Yeomans was taught Northwest Coast design by his aunt Freda Diesing and studied fine arts at Langara College in Vancouver. He worked with Robert Davidson on the Charles Edenshaw Memorial Longhouse and completed a jewellery apprenticeship with Phil Janze. His work is in the Glenbow Museum in Calgary, Alberta; Canadian Museum of Civilization; University of British Columbia Museum of Anthropology; Royal British Columbia Museum, and Museum of Northern British Columbia, Prince Rupert.